IMAGES
of America

EAST ORANGE

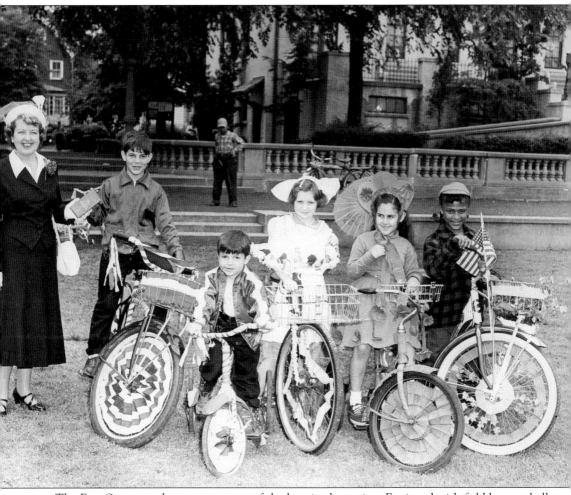

The East Orange park system was one of the best in the nation. Equipped with field houses, ball fields, swing sets, lawn bowling, ice-skating, racetracks, tennis courts, picnic facilities, and unique items such as jets, covered wagons, and boats, there was entertainment for all. This photograph was taken around 1955 in Soverel Field.

On the cover: Please see above. (Courtesy of East Orange Public Library.)

IMAGES
of America

EAST ORANGE

Bill Hart

ARCADIA
PUBLISHING

Published by Arcadia Publishing
Charleston SC, Chicago IL, Portsmouth NH, San Francisco CA

Printed in the United States of America

Library of Congress Catalog Card Number: 2006924319

For all general information contact Arcadia Publishing at:
Telephone 843-853-2070
Fax 843-853-0044
E-mail sales@arcadiapublishing.com
For customer service and orders:
Toll-Free 1-888-313-2665

Visit us on the Internet at www.arcadiapublishing.com

To my mother, Joan Dougher Hart, and in loving memory of my father, William Stanley Hart. Their sacrifices made all the difference.

CONTENTS

Acknowledgments 6

Introduction 7

1. Early History 9

2. Founders and Builders 15

3. Government Institutions 25

4. Schools and Colleges 39

5. Churches and Temples 57

6. Around Town 65

7. Old Houses 79

8. People of East Orange 89

9. Recreation and Fun 101

10. Celebrations and Farewells 113

Bibliography 128

ACKNOWLEDGMENTS

As in my previous two books, I would first like to thank my wife, Andrea Alam Hart. Her love, support, and assistance on these projects are incalculable, and I could not do it without her.

Second, I wish to thank J. Robert Starkey, head of adult reference at the East Orange Public Library, who kindly gave me access to all of the photographs and research materials I required to write this book.

Third, I wish to thank the East Orange Public Library for preserving these materials and making them accessible to me. Without the library's foresight and assistance, this manuscript would not have been possible.

I want to thank my Warrington Place friend Andrew Fedors for once again assisting me in the sorting and collection of photographs from the library. Due to some library construction, it became necessary for he and I to get "down and dirty" and move a good amount of furniture to get to the old filing cabinets. Without his help I might still be digging my way to them.

Kevin Dilworth, *Star Ledger* reporter, was invaluable to me when it came to researching obscure information. He and I have become good friends since I wrote *East Orange in Vintage Postcards*. His access to sources unavailable to me was extremely useful.

The Glen Ridge Public Library was kind enough to share with me a dozen or so photographs they had of East Orange houses. I would like to thank the library for the courtesy of the loan.

A number of individuals assisted me in the writing of this book. Specifically, I would like to thank Savanna Jackson, attorney, who reviewed my Arcadia contract; Shirl Jackson, author of *Annie Oakley*, who provided me with the obscure reference proving that Annie lived in East Orange; Ivonne Kratz and Barbara Fay, reference librarians at the East Orange Public Library; Paul Clarkson; Kathleen and Geof Condit; June Condit Henry; Don Koks and Frederica Merrivale, for their wonderful Web site on Betty Bronson and personal assistance; Ann Harris, Simon Rucker, and Karen Everson, for their work at the Tisch School of the Arts, New York University; Susan Plese, who shared so many Upsala College memories; David Irving, for his East Orange and Clifford J. Scott High School memories; retired navy captain Frederick M. Pennoyer III, for information on his father; Kathryn Jenney Lesko, for information on Clara Maass; Dionne Warwick, for the long interview; Bill Butterworth, who also granted a long interview; Butterworth's assistant Donna Kenny, who put up with my persistent calls; Guy Sterling, *Star Ledger* reporter; and Pam O'Neil, my editor at Arcadia, for her guidance, support, and patience.

To all of the above, I give my heartfelt gratitude and affection.

INTRODUCTION

I had not yet even completed *East Orange in Vintage Postcards* when I knew that I wanted to write a second book on East Orange. So much of the story had been left untold.

While I had more than enough postcards to do a second East Orange book, my desire was to instead write an East Orange book in the Arcadia Images of America series. Postcards, by their very nature, tend to be of things, like streets and buildings. I wanted to show the people who founded and built East Orange. That was the biggest part of the untold story in *East Orange in Vintage Postcards*. The problem was that I did not own enough photographs to do a book.

So I contacted J. Robert Starkey at the East Orange Public Library and luckily the images were there. Many had been stored by the library for years in filing cabinets. Glued to cardboard backing, they were available for a long time to any who wanted to see a photograph of a particular scene—sort of like an early internet service. Others had been donated by the East Orange Historical Society when they went defunct in the 1960s. Still others came from government offices after big celebrations, such as the semi-sesquicentennial of 1938. The Little Theater of East Orange left hundreds of photographs with the library as well as the rest of their records. All of these were made available to me.

East Orange is an attempt to tell more of the story that made that city so great. In it, the reader will have the opportunity to meet some of the founders and builders, people who brought East Orange from a village to a city in less than 40 years. The famous people from East Orange come to life, those who were either born or lived in East Orange and went on to national fame. In this volume, the reader will discover more about the schools, churches, and government institutions, but they will get to see some of the faces associated with those places. Finally, East Orange allows a closer look at what the people did for fun and how they celebrated life and events.

Like *East Orange in Vintage Postcards*, *East Orange* is primarily an early history. Most of the photographs range from about 1876 to 1978, or from the nation's centennial to the 300th anniversary of the settlement of the Oranges. The concentration, however, is on the late 19th and early 20th century, and most of the history covers the founding in 1863 to the centennial in 1963.

The problem in writing a book like this is not what to choose to put in it, but what to choose to leave out of it. There were dozens of photographs I wanted to use, but space would not allow. Given the choice between two photographs of similar quality, I choose the older, deeming it to be of more interest to the reader and also more necessary of preservation. Perhaps a third book on East Orange is somewhere in the offing.

As last time, while writing *East Orange* has been difficult, it has been fun. Everyone has his or her hobby, and this is mine. The city that was once one of the wealthiest in the nation,

with a premier fire department, police department, school system, and government, was my home for 24 years. I still remember fondly the parks, stores, movie theaters, beautiful streets, and grand homes.

Like many urban cities, East Orange has had its difficulties over the years, but it is in the midst of a renaissance. Old buildings are coming down and being replaced with lovely houses and condominiums. Dr. Martin Luther King Jr. Boulevard (old Main Street) and Central Avenue are being revitalized. As I write this, the old Hollywood Theater is being reopened as a multiplex. Like a phoenix, East Orange is rising again. Ironically, much of that redevelopment is centered around the Brick Church station—the area where it all started when Matthais Odgen Halsted decided to build a house and flag down a train. If history does repeat itself, East Orange is destined to become a queen again.

However, there is sadness in this renaissance, as many old buildings must be torn down in the process. The week I wrote this introduction saw the razing of the western campus of Upsala College. A week later the city began to tear down East Orange High School. This process is necessary, of course, but it makes me even more glad for the Arcadia series of books that helps to preserve what has been lost.

Photographs are sharper images than postcards, but they are not as durable. The photographs shown here, as mentioned previously, came primarily from a library, and have had much handling. As a result, the reader may notice that some have tears or holes. However, this does not detract from their overall wonder. Similarly, photographs are a little more difficult to date than postcards, which often have postmarks. Unless the photograph was clearly marked on the back I made my best estimate, based on things like dress, cars, flags, and so on. I cannot guarantee that I was always correct. I am also certain there were a few I completely misidentified in spite of careful research.

Identifying streets and buildings is pretty easy. Identifying people is easy only if their names are provided on the photograph. This was not always the case, so, sadly, many of the people captioned here will go unidentified.

There are almost 200 images in this book. Unless otherwise credited, all photographs are courtesy of the East Orange Public Library and all postcards used are from the author's collection (AC). I have tried to provide each reader with a comprehensive view of "old East Orange" and at least one fond memory of the city.

I hope I have succeeded.

One

EARLY HISTORY

The history of East Orange actually begins in 1662 when the Connecticut and New Haven colonies were combined. The New Haven colony had been a theocracy, and many of the Puritans who lived there were not pleased that their newly united colony would not be led by their church. In hope of finding a new land to settle, Milford residents sent forth Capt. Robert Treat and John Gregory in early 1666 to find such a land.

Upon their return, Treat and Gregory reported they had found such a place in East Jersey and under the control of Governor Carteret. Meadows, forests, rivers, fur-bearing animals, fowl, fame, and streams were all available. Preparations were made. Land was purchased from Carteret for "quit-rent of half-penny per acre per annum." Early in May 1666, the Milford Company, accompanied by residents from nearby Guilford and Branford, set sail for the "Pesayak" River under the command of Robert Treat.

Landing on the shore of the Passaic River, in what is now Newark (the exact site remains unknown), the colonists unloaded their livestock, household goods, and tools of survival. Initially there was a glitch. The land had not been purchased from the native Hackensack band of the Lenape as promised by Carteret. The Puritans, an honest people, began to reload their goods, but Governor Carteret appeared before the loading was completed, admitted his error, and the deal was negotiated. The purchase was made with Perro, a minor chief, and the land bought for a quantity of goods and wampum. The deal was finalized on July 11, 1667. The land purchased stretched roughly along the Newark Bay northward to the "Pesayak" River, west to the foot of the Watchung Mountains, along the base of the mountains to the "Weequachick" River, and then east again to the bay, or approximately what makes up Essex County today.

Before landing, these same Puritans had written a constitution, known as the Fundamental Agreement. Only church members were allowed to vote on laws, but nonchurch members were allowed to own property and grant all civil liberties. Within short order, colony members were heading west toward the mountains, settling what soon became known as High Street. It became apparent that even more land was needed than had been acquired in the original purchase. In March 1678, Daniel Dod and Edward Ball were sent to survey and extend the northern line of Pasayak Towne to "the top of the Mountain." This land was then purchased from the Winacksop and Shenacktos bands of the Lenape. The price was "thirteen kans of rum, three coates and two guns." While surveying the area, Daniel Dod had selected for himself a large holding near the Watsessing Plain. This is believed to have been the first settlement in the Oranges. Together with his sons Daniel, Stephen, John, and Dorcas, Daniel Dod began to settle the land he had claimed in the vicinity of what is today the corner of Dodd Street and Midland Avenue. This photograph was taken from the Cable Road in West Orange atop Orange Mountain in 1899. This view looks east toward Orange and East Orange, and the spot from which it was taken represents an area close to the westernmost boundary of the original Newark Settlement of 1666.

In 1720, near the north side of what is now Dodd Street and just east of Brighton Avenue, copper was discovered on John Dod's land. He owned about 500 acres on the Wardsesson (Watsessing) Plains. Mining began immediately and with it an influx of people and capital. The mine operated until about 1760. This photograph, from 1908, shows a shaft found under the Bethel Church.

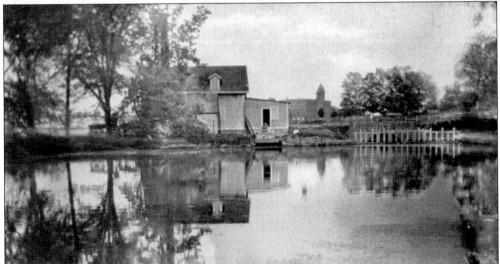

About the time of his mining adventure, John built a gristmill. It was powered by the water of the Second River and located near the spot where the Watsessing Park field house stands today. People from around the area brought their grain to John for grinding. This photograph, from 1884, shows the second gristmill built on that spot.

Matthais Soverel, eldest son of William and Betsy Wright Soverel, was deeded the 22-acre John Wright homestead by his mother in 1841. It was located near today's Springdale Avenue and North Park Street. In 1854, Soverel flooded part of his farm from the Second River and built two lakes, from which he began an ice business. This photograph was taken around 1872.

Besides farming, mining, and milling, one of the earliest industries in East Orange was hat manufacturing. The first such pioneer in East Orange was Cyrus Jones, who in 1790 built a home and factory near what was later Main Street and North Munn Avenue. Shown here is the John Ray factory, built around 1845 and probably located north of Dodd Street at the end of Long Street.

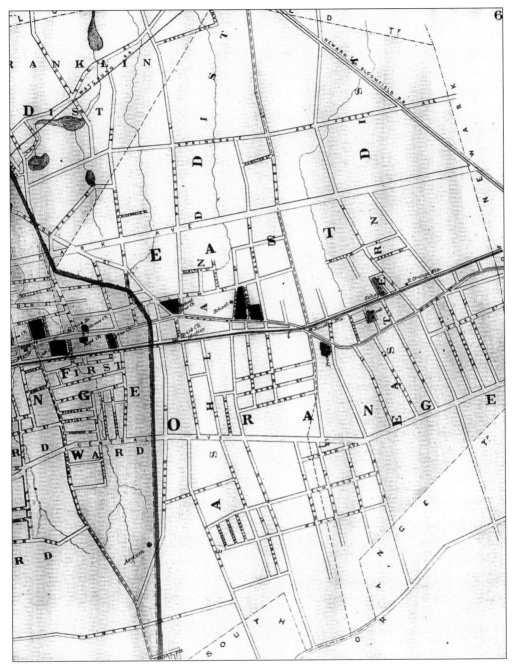

This map of East Orange is from 1872, nine years after the town spun off from Orange. At this time, East Orange was formed into three school districts: Franklin, Ashland, and Eastern. Notice that many streets have different names today. For example, Arlington Avenue was called Cherry Street. (AC.)

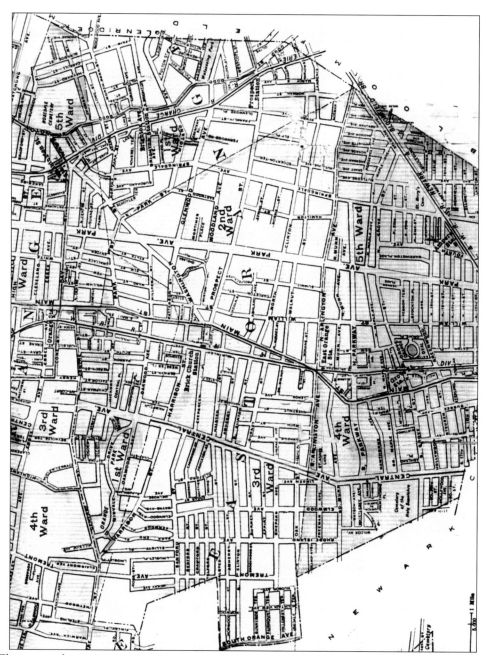

This map is from 1918. By this time, most of the streets in East Orange were completed and had their current names. The city is clearly divided into five wards, with Doddtown being the First Ward, Ashland and Brick Church being the Second Ward, Elmwood being the Third Ward, Pecktown being the Fourth Ward, and Ampere being the Fifth Ward. (AC.)

Two

FOUNDERS AND BUILDERS

The founders of the Newark colony spread west to the Orange Mountain, using the pastures for grazing their livestock and building farms, mills, hat factories, and mines. Samuel Dod, cousin to John, constructed a sawmill downstream from John's gristmill, damming the second river and creating Dodd Lake (now part of Watsessing Park). Many farmers planted orchards. Cider became not only a staple, but also a cash crop.

The people west of Newark, referred to as the Mountain Society, were still part of the Newark town and were required to attend town meetings and church services. As they moved farther west, this became increasingly difficult. A schism began to grow. The people of the town remained staunchly Puritan, but the Mountain Society was more liberal.

In the early 1700s, the Mountain Society people began to discuss building a new meetinghouse in their own area. Finally, around 1720, 20 acres of land was acquired off of the south side of what would become Main Street in Orange across from what is today the military common in Orange. In that same year, a frame building was constructed of lumber and the First Meeting House of the Mountain Society was instituted.

The name Orange was probably first used to describe the area in 1757 by Caleb Smith, naming the location to honor the memory of King William III of the House of Orange and Nassau. However, it was 1780 before the name was formally adopted.

The American Revolution did not bypass East Orange. In 1776, the Jones home at Main Street and Munn Avenue was plundered. John Wright, John Tichenor, and Joshua Shaw battled three Highlanders at Peck Hill (Main Street and Munn Avenue). The former were victorious, but John Wright was wounded. The biggest battle occurred at the East Orange/Bloomfield line on the Wardsesson (Watsessing) Plain. On September 13, 1777, members of the militia attacked the British in the area of what is now Glenwood Avenue, north of Dodd Street. Several militiamen were wounded, but none were killed; however, several of General Clinton's British soldiers died. Shown here are Wallace Montgomery Soverel and his second wife, Josephine. They resided at 600 Springdale Avenue, the Soverel homestead. The first Soverel to arrive here, Abraham, came to New Jersey from England in 1739 and mined in the Orange area until 1745. He married Jane Williams in 1741. They had one son, Matthias, who was born and raised at his mother's house near Washington and Park Streets. His grandson William Parret Soverel married Betsy Wright, daughter of John Wright. Wallace was the grandson of William.

Daniel Dod was born in Branford, New Haven, and came with that group of settlers to Newark around 1667. This progenitor was responsible for the settling of the Doddtown area of East Orange. Shown here is one of his many descendants, Samuel Morris Dodd, who was born in East Orange in 1832 and later became a leading St. Louis merchant.

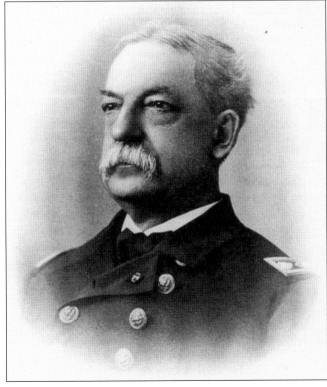

John Peck was the first of that family to come to East Orange, buying a large tract of land near Main Street and Maple Avenue, an area that would come to be known as Pecktown. Pictured here is one George Peck. He was born in 1826, graduated the College of Physicians and Surgeons in 1847, joined the navy, and later served as a surgeon for the Union naval forces during the Civil War.

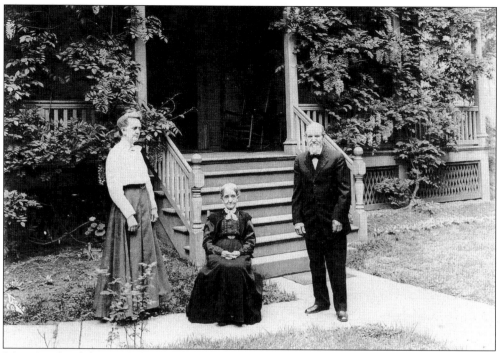

John Cunditt (also spelled Condit or Condict) came to Newark from England in 1678. His descendants moved to the Orange Mountain area. Jotham Condit was the first of his line to locate to East Orange on Main Street below South Clinton. Shown here are Sarah Elizabeth Butterworth Condit, Elizabeth Whittaker Condit, and Joseph Wood Butterworth in front of the Condit home on Dodd Street. (Courtesy of Condit/Henry families.)

The first Stetson hat factory was built in East Orange by Stephen Stetson in the 1830s and was located on Main Street in the Brick Church section. He later moved the factory to Orange, where it came to be known as the No Name Hat Company. Stephen's son, John Batterson Stetson, became the maker of the famous Stetson cowboy hat. Shown here is John's cousin Henry, who became president of the No Name Hat Company in 1893.

Sgt. Richard Harrison was one of the Branford signers of the Fundamental Agreement. His grandson Samuel moved to what is now Orange in 1723. Shown here is descendant Ira Harrison, who married Mary Jones of the Jones family that settled the northwest corner of Main Street and Maple Avenue. Nathaniel Harrison, born in 1705, had a farm on the ridge through which Harrison Street now runs.

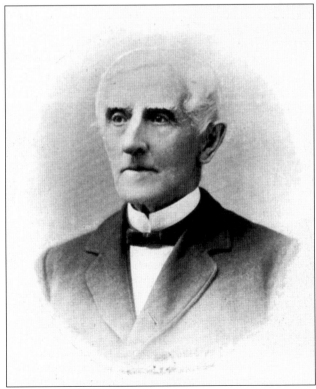

Benjamin Baldwin probably came to Newark with the original settlers in 1666. He was married to Hannah, daughter of Sgt. Richard Harrison. The main homestead was on the South Orange side of the South Orange/East Orange border off Munn Avenue. Shown here is Caleb Baldwin, who in 1836 opened a country store on Main Street in East Orange.

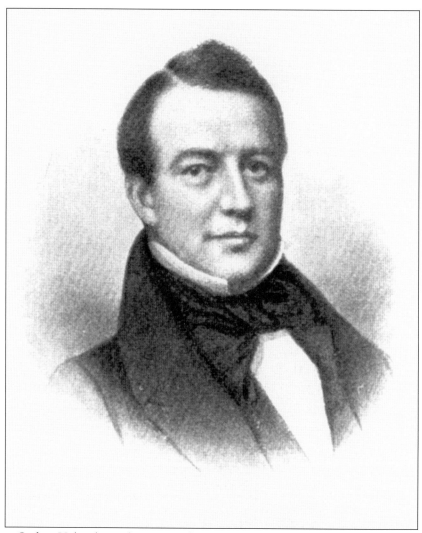

Matthias Ogden Halsted was born on July 12, 1792, in Elizabeth. He attended Princeton University and then studied law. He practiced law in Warren County for several years and then became a partner in Halsted, Haines and Company of New York City, one of the largest dry goods firms in the United States. Among the firm's customers was one of the Condit family, who owed the company a large debt. Amos Condit offered his 100-acre farm located off Main Street in East Orange as payment. Halsted assumed the farm into his personal account, paid the company, and took ownership of the farm. In 1838, he moved to East Orange. Two years later, he built a large mansion on the land. The Condit land, known as the Gruett farm, fronted on Main Street between what later became Halsted Street and Clinton Avenue and then extended south to the South Orange border. Halsted bought another adjoining 30 acres. He laid the land out in plots and had houses built for his two daughters and then built additional houses and enticed his New York friends to buy them. At this time, the Morris and Essex Railroad, established in 1836, had no official stop in East Orange, but the train stopped for Halsted anyway to take him to work. In gratitude and at his own expense, Halsted built a train depot near Brick Church, put a man and woman in charge, and gave it to the railroad. This occurred around 1864. Thus, Halsted became the first "developer" in East Orange. Halsted Street is named for him. He died on June 12, 1866, and is buried in Rosedale Cemetery in Orange.

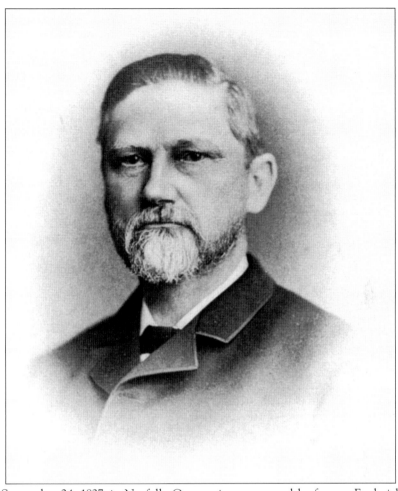

Born on September 24, 1827, in Norfolk, Connecticut, to a wealthy farmer, Frederick Michael Shepard moved to New York in 1848. In 1861, with Joseph A. Minott, also of East Orange, Shepard founded the Rubber Clothing Company and was named its president. He was named president of the Union India Rubber Company in 1870. Two years later, he and Minott founded the Goodyear Rubber Company. (Note, this was not the same Goodyear Rubber Company we know today.) Among his other credits were director in the National India Rubber Company, president of the Lambertville Rubber Company, director of the U.S. Rubber Company, director in Mutual Benefit Life Insurance Company, and member of the Orange Memorial Hospital Committee. Shepard moved to East Orange in 1868, purchasing a summer home on Munn Avenue. He kept a residence in New York and then made East Orange his permanent home in 1873. Shepard took over the floundering Orange Water Company in 1880 and became president. It soon flourished. The resulting water for homes and fire hydrants led to further East Orange development. Shepard was instrumental in building the Commonwealth Building on Main Street and Arlington Avenue, which housed the Orange Water Company, East Orange National Bank, S&J Davis, the East Orange Post Office, and other businesses throughout its life. It even acted as an early city hall. Shepard organized the East Orange Safe Deposit and Trust Company and was its first president. He deeded a 250-foot strip of his own property to be used for Essex County Boulevard. He was a founder of the Elmwood Presbyterian Church and superintendent of the Sunday school, as well as a commissioner of the Essex County park system. Shepard died on June 13, 1913. Shepard Avenue is named for him.

Joseph Albert Minott was born in Albany, New York, on March 15, 1836. He moved to East Orange in 1858. Together with Frederick Shepard he founded the Rubber Clothing Company in 1861, and the Goodyear Rubber Company in 1872, and served as secretary and treasurer of both companies. In 1880, Minott erected one of the finest houses in East Orange on Arlington Avenue and in so doing, attracted other wealthy individuals to do the same.

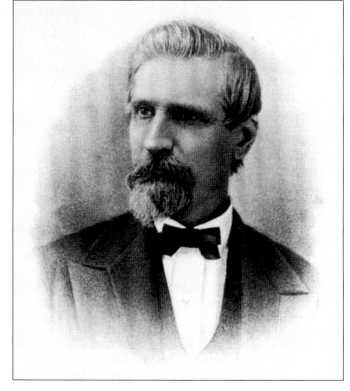

John Merchant Randall was born in Rutland, Vermont, on August 18, 1818, and moved to East Orange around 1856. Randall was in the lumber business and owned one of the largest distributors in the nation. Randall built a beautiful mansion on South Munn Avenue near Main Street. He was a member of the first township committee. He died in 1895.

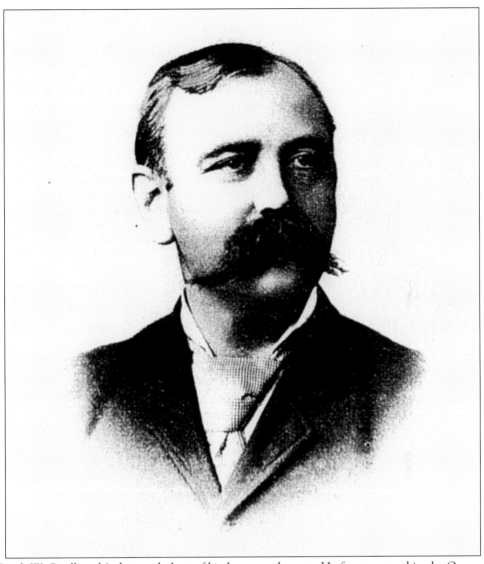

Frank W. Coolbaugh's date and place of birth are not known. He first appeared in the Oranges in 1876, when he rented a house on Webster Place. Coolbaugh was a train dispatcher for the Delaware, Lackawanna and Western Railroad. Concerned about train safety, he developed several improvements and had them patented, then left his railroad job to begin marketing his inventions. In 1886, he made his first dabble in real estate by buying land on a poorly developed area on Burnett Street near the railroad tracks. The house, designed by his wife, was so impressive it was featured in *American Scientific Magazine*. In 1890, Coolbaugh bought land on the corner of Orange (Lennox) and South Walnut Streets and built a new home for himself. He next purchased a swampy area of land bounded by South Burnett Street, South Arlington Avenue, Beech Street, and Central Avenue. Coolbaugh created two new streets. The first, running east and west, he named Carnegie Avenue after Andrew Carnegie. The next, running north and south, he named Shepard Avenue, after Frederick M. Shepard. At the junction of these two streets he created a circle 50 feet in diameter and populated with seven trees. The area came to be known as "Seven Oaks Circle." About 150 houses were built on these two new streets in the 1890s. Coolbaugh disappeared from East Orange, leaving somewhere around 1896.

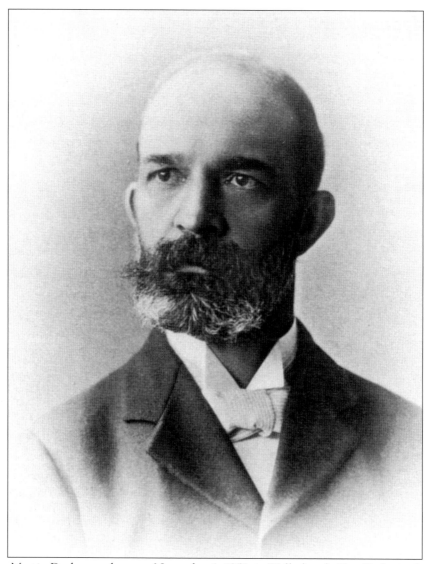

Charles Martin Decker was born on November 1, 1850, in Wellesburgh, New York. At the age of 14, he came to Orange and took a job in a grocery. In 1871, he bought out his former employer, Mr. Cairnes, with a partner named Abraham Johnson. Decker and Johnson's store was located at the corner of Main and Washington Streets in East Orange. In 1874, Decker bought out Johnson and relocated to 539 Main Street at the corner of Washington Place. In 1882, he was joined by his brother Caton, and seven years later by brother Guy. The brothers formed a chain of stores in the Oranges, later branching out to surrounding towns. Charles M. Decker and Brothers was successful because of the innovative methods he employed. To capture the New York trade, he stocked his shelves with the finest goods. He established free home delivery. He offered credit. Decker sent quarterly magazines to his clients advertising products and prices. Decker was president of the Orange National Bank, a director of the Savings Investment and Trust Company of East Orange, and a director of the Orange Trust Company. Like the other successful men of East Orange, he was a staunch Republican. Decker and his wife, Harriet, lived on William Street. Harriet was a member of the Peck-Jones line. Charles moved to Madison in 1892. He died on August 28, 1920, and is buried in the Rosedale Cemetery in Orange.

Three

GOVERNMENT INSTITUTIONS

By the start of the 19th century, it was apparent that the Mountain Society in the area, now referred to as Orange, was in need of forming its own township. On Tuesday, October 14, 1806, Maj. Amos Harrison was elected to the general assembly and charged with entering a bill to incorporate Orange. The new legislature convened on October 26, and on November 27, the incorporation of Orange was passed. The first town meeting was set for the second Monday in April 1807, at the town meetinghouse. A committee was elected, and the next day, Tuesday, April 21, 1807, at Samuel Munn's, the committee elected Stephen D. Day as chairman. The new town covered much of what is today Orange, East Orange, West Orange, and South Orange.

Orange continued to grow and prosper, but with that came even more differences of opinion and purpose. The section that would become South Orange broke off in 1835 and with Millburn formed the town of Clinton. Things continued pretty much the same until about the time of the Civil War. On January 26, 1861, South Orange became its own village. A year later, on March 11, 1862, West Orange formed the town of Fairmount with what would later become Caldwell and Livingston.

In 1860, Orange filed to incorporate as a township. The government wanted to raise funds for police and fire departments as well as to light the streets and macadamize the roads. The people in the eastern section of Orange, now East Orange, were not in favor of these changes. They were not concerned about the overcrowding and crime problems that were occurring in the western part of the town. However, the incorporation passed on January 26, 1860, and Orange was divided into three districts. The first ward encompassed what would become East Orange.

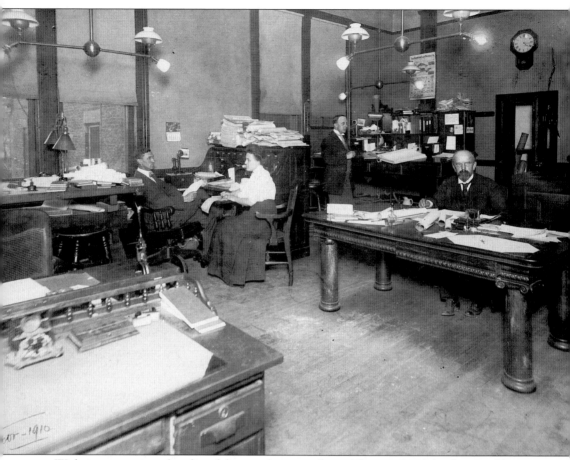

With incorporation, the idea of division began to fester. The people of the first ward began to prepare a law that would separate them. Orange fought back. The first ward was the wealthy ward, and their tax dollars were needed. The separation bill was presented to the state legislature on February 3, 1863. The arguments were vigorous, but the legislature was leaning toward allowing a separation. The Orange delegation suggested a compromise, but the first ward delegates, sensing victory, turned them down. On March 4, 1863, the bill was made law and East Orange was born. An election for a township committee was held in April 1863. The polling place was Timothy W. Mulford's wheelwright shop on Main Street, just east of Burnett. The elected committee then met at the office of Moses Williams at 251 Main Street. William King was appointed chairman, Joseph Munn was elected clerk, and Amzi Dodd was chosen as township council. Other members were John M. Randall, Aaron B. Harrison, Charles Crane, and Elias O. Doremus. Pictured here is the engineer's office in the old city hall building in November 1910. From left to right are Frederic A. Reimer, city engineer; Alice I. Webster, secretary for all city hall departments and who later became city clerk; unidentified; and William H. Brown, clerk for street and sewer departments from 1900 to 1907.

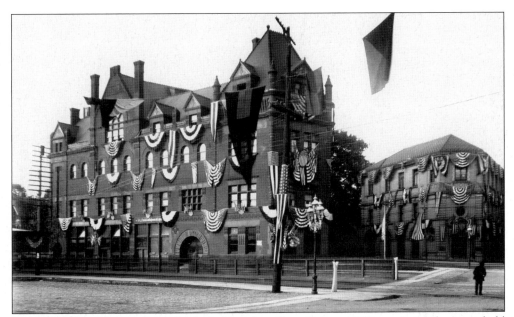

Initial town meetings continued to be held at the office of Moses Williams. Later they were held at the Ashland School and at the "Public Hall and Reading Room" on the southwest corner of Main and Grove Streets. Upon the construction of the Commonwealth Building in 1887, by the Orange Water Company, shown here in 1907, meetings were held there.

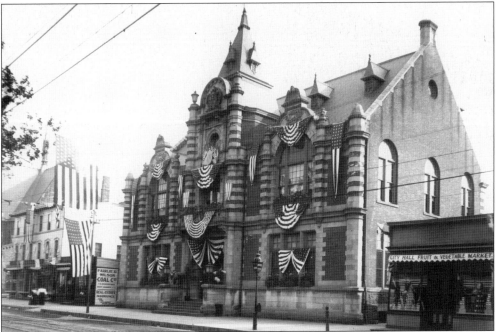

In 1892, a municipal building was constructed on the north side of Main Street between Winans and Walnut Streets. The town administration used the front of the building, the police department used the rear. By the end of the 19th century, it was apparent that East Orange, with a population of 30,000, needed a larger building. The gingerbread city hall building, shown here in 1907, was built in front of the old municipal offices and was occupied on December 1, 1899.

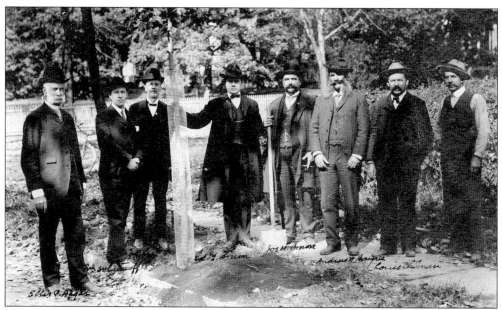

East Orange residents voted to incorporate East Orange as a city on December 9, 1899. Township committee president Edward E. Bruen was sworn in as mayor in the new city hall. Shown here is the newly created Shade Tree Commission on October 19, 1904, planting its first tree. From left to right are Ellis Apgar, William Solataroff, Joseph Lee, Mayor Bruen, Joseph Brown, Andrew Baigrie, Louis Olhman, and an unidentified workman.

With continuing growth came continuing needs. A new civic center consisting of a city hall, police department, and health department was constructed on the north side of Arlington Place, between North Munn and Arlington Avenues. A new post office completed the square. The new city hall, shown here, was dedicated on September 21, 1929.

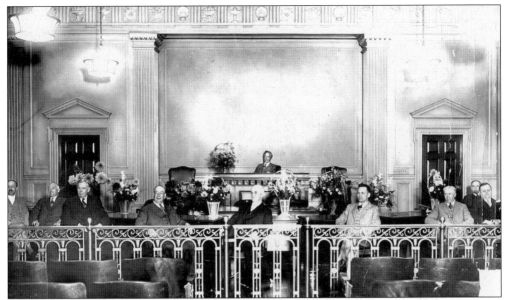

The first meeting of the city council in their new chambers, captured here, was held on September 23, 1929. On the dais is council chairman Frank E. Quinby. From left to right are William Dailey, Cyrus Vail, Edwin Ellor, Frederick Rauch, William Metz, Harry Lindeman, Nathaniel Gardner, Christopher Morrow, and James Owen.

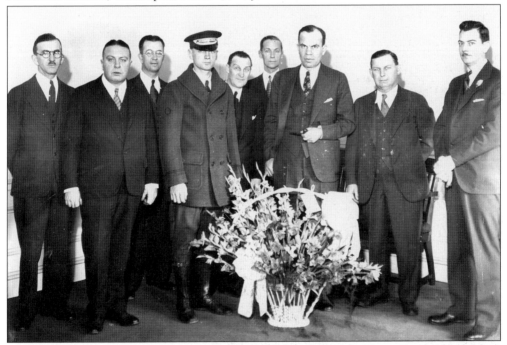

Charles H. Martens, first elected mayor in 1918, was reelected 17 more times, a record number in the United States at that time. Single-minded in his quest to make and keep East Orange great, the Republican politician finally retired in 1952. March 8, 1952, was declared "Martens Day." Ashland Stadium was renamed Martens Stadium. Martens died in September 1955. He is shown here on March 27, 1933, third from the right.

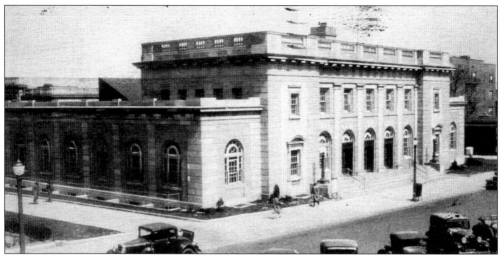

The first East Orange Post Office was located in the Junction Train Station on February 15, 1869. The office was relocated to the Doan Building on the northwest corner of Arlington Avenue and Main Street in 1886. Other locations later included the Commonwealth Building. The building shown here was built on the northwest corner of Arlington Place and Munn Avenue, and dedicated on September 21, 1929.

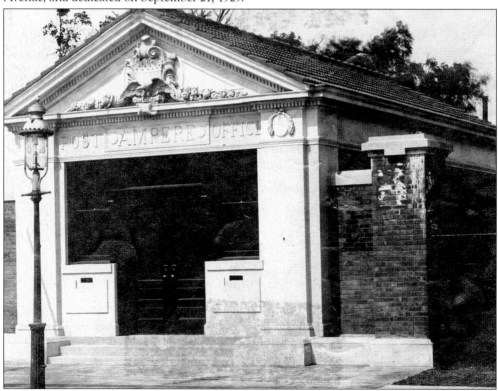

The Ampere section of East Orange was almost a community unto itself, brought to life by the arrival of the Crocker-Wheeler Company. Crocker-Wheeler built its own post office building in 1895. Shown here and located on the north side of Fourth Avenue east of Sixteenth Street, the Ampere Post Office served the local community for many years.

Founded in April 1885, the East Orange Police Department was first housed in a frame structure on the north side of Main Street between Walnut and Winans Streets. Later they moved to a brick structure on the same spot. They finally occupied brand-new quarters in 1929. Shown here is a photograph of Ezra Lake taken on July 3, 1889. The back reads, "Captain, 9th Police Department, East Orange." (AC.)

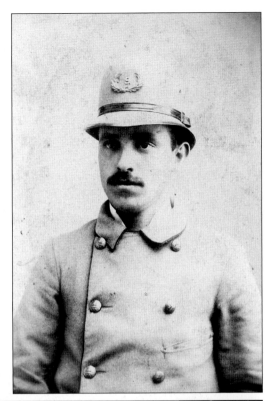

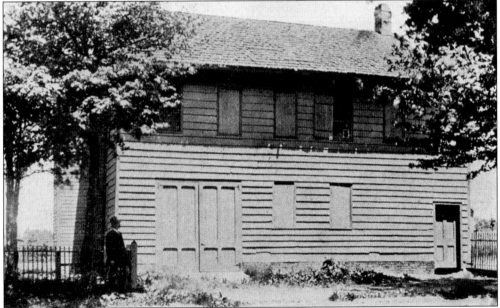

The Ashland Hook and Ladder Truck Company was founded on January 25, 1879—the first fire department service to exist in East Orange. They acquired a secondhand truck on February 5, 1879. Three years later, the Ashland Hose Company was founded. Seen here is the Franklin Hose Company No. 3, created on April 14, 1884, and located on the southeast corner of Dodd Street and Brighton Avenue in the original Franklin Schoolhouse.

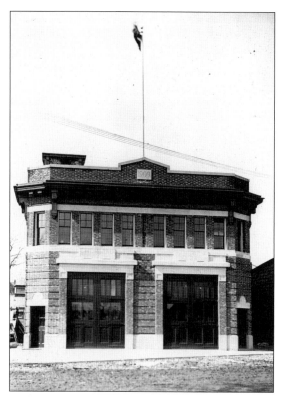

The Eastern Hose Company No. 2 was established on December 11, 1883. Located in a frame building on the corner of Grove and Main Streets, they moved in August 1888 to a brick building located on the northeast corner of Main Street and Hollywood Avenue. This building, constructed in 1909, was located farther north on Hollywood Avenue.

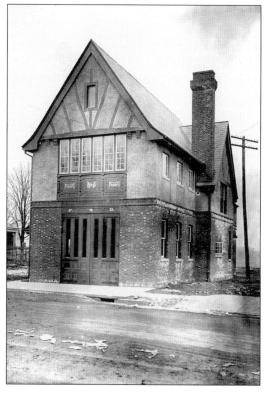

On June 11, 1883, the East Orange Fire Department was officially created. Hose Company No. 4 was established on October 1, 1906, and located in the old Driscoll Disposal Works building on Springdale Avenue north of Centre Way. They then moved to this building at the corner of Ampere Plaza and North Eighteenth Street and remained there until 1930.

Elmwood Hose Company No. 5 was created on September 12, 1887, and occupied a frame building on the southwest corner of Elmwood Avenue and North Clinton Street. In January 1895, this brick building was ready for occupancy. It fronted on Elmwood Avenue. By March 1907, the East Orange Fire Department had no volunteer companies.

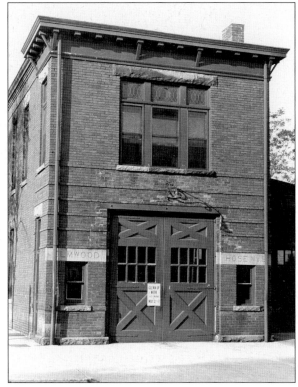

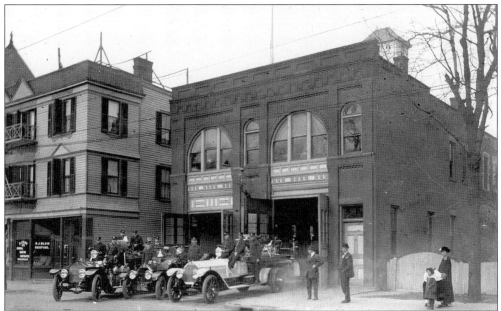

The Ashland station was relocated to the north side of Main Street east of Ashland Avenue around 1890 and became the main headquarters. This c. 1915 photograph shows three of the company's "trucks." The building on the left houses B. J. Blair Roofing. For many years, the National Board of Fire Underwriters gave the fire department a "Class A" rating, resulting in lower insurance rates for the East Orange citizens.

This photograph is of the laying of the cornerstone of the main branch of the East Orange Public Library, located on the southeast corner of Main Street and Munn Avenue. It was taken on October 29, 1901. The building was funded by a $50,000 grant from Andrew Carnegie, arranged in part by his East Orange friend Alexander King. The main branch opened on January 22, 1903.

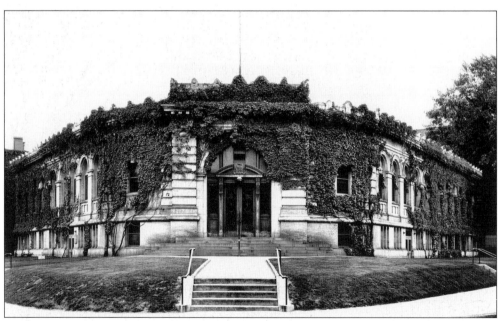

The library was expanded in 1915 with an additional Carnegie grant of $40,000. This 1926 photograph shows the expanded library. To the left is Main Street and to the right is South Munn Avenue. Not all of East Orange's residents were in favor of Carnegie's gifts. Some felt insulted. Dr. J. M. W. Kitchen stated, "We are a wealthy community able to provide for our own library."

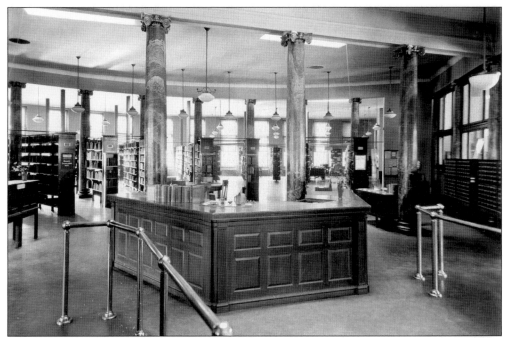

This 1925 view shows the lending department. The library designer was Hobart A. Walker. Alexander King, who arranged the Carnegie gift, was from Scotland and had introduced Carnegie to his wife. He lived on North Walnut Street. He died in 1913, shortly after being struck by a car, and was interred in Rosedale Cemetery.

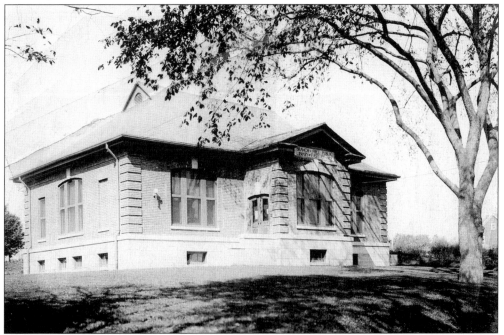

The Franklin Branch, located on the northeast corner of Dodd Street and Franklin Avenue (now Cleveland Terrace), was opened on August 1, 1909, and also funded by a Carnegie gift of $13,000. Fronting on Dodd Street, the branch was enlarged in 1939 to twice its original size.

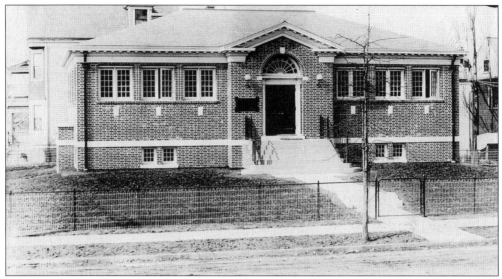

A fourth gift of Andrew Carnegie, also in the amount of $13,000, resulted in the construction of the Elmwood Branch. Located on the northwest corner of South Clinton Street and Elmwood Avenue, the branch was conveniently placed across the street from the Elmwood School. It opened on January 11, 1912. The photograph was taken in 1913.

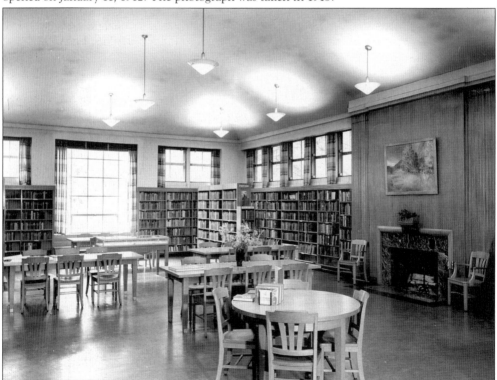

Although not as elaborate as the main branch, the Elmwood Branch was constructed with beauty and tranquility in mind. Shown here in this October 1944 photograph is the adult department, complete with fireplace, painting, flowers, and plenty of sunlight. Besides the Elmwood School, this branch was close to the Washington School and St. Joseph's.

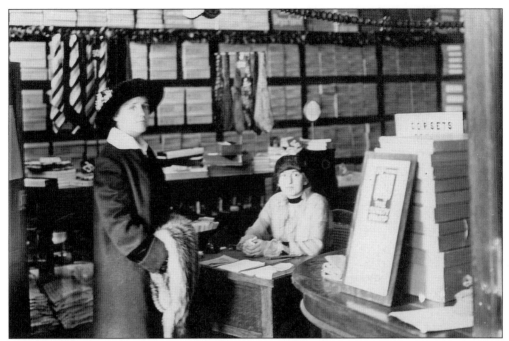

The East Orange Public Library opened a deposit station for its Ampere customers in 1915. Located at 67 Fourth Avenue, in the Roche and Stone dry goods store, clients were able to drop off borrowed books there. Shown here are Miss Davidson (standing) and Miss Buchner.

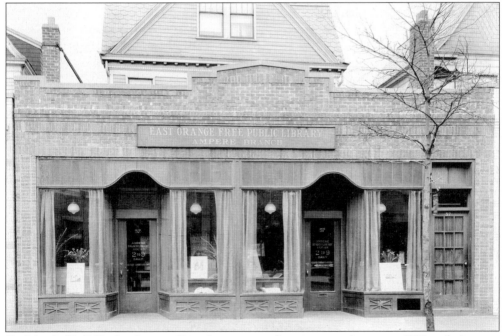

On March 17, 1923, the Ampere Branch was opened in two rented stores at 57 Fourth Avenue, shown here on April 1, 1927. The sign on the doors says "Open 2 to 9 daily. Closed Sundays and Holidays." The store building was probably very new, as in 1920, the only listing there was for "James Herron." That residence can still be seen behind the library.

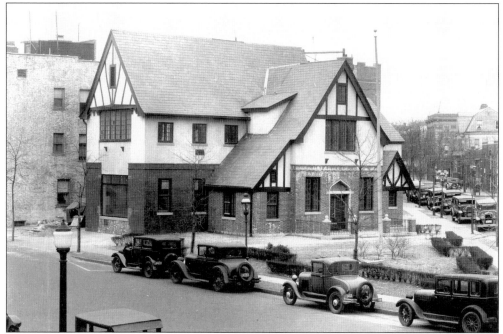

In 1931, the Ampere Branch acquired a building of its own at the corner of Ampere Plaza (left) and North Eighteenth Street (right). The building, shown in an earlier photograph, was the old Ampere firehouse. Just beyond, in this c. 1931 view, on the right, was the Ampere Theater at 225 North Eighteenth Street.

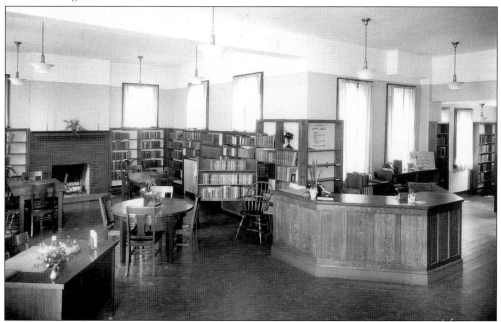

Taken on July 16, 1931, this photograph shows the interior of the newly opened Ampere Branch. Shown here is the adult room. A little less elaborate than its Elmwood cousin, the branch also sports a fireplace, candlesticks, plants, and abundant windows. The Ampere Branch was in close proximity to the Ampere Train Station, Columbian School, and Our Lady of All Souls School.

Four

SCHOOLS AND COLLEGES

East Orange was divided into three school districts: Franklin, Ashland, and Eastern. While there were Latin schools (grammar schools) dotted throughout the area during Colonial times, the first known schoolhouse in East Orange was probably built before the Revolutionary War and located on Main Street between Washington and Prospect Streets. It was a stone building, one floor, and about 22 feet by 40 feet. Equipped with slab benches and desks built into the walls, its sole source of heat was a box stove in the middle of the room. The school was funded by tuition, with students coming from miles around. This first school building was condemned in 1804.

The Ashland School was located on Prospect Street behind Brick Church. It was known as the "little white schoolhouse" and was constructed in 1805 to replace the first schoolhouse. The first floor was used for classes, the second remaining unfinished for several years. The building was white with red gables.

On March 13, 1825, Doddtown residents passed a resolution to build "the Franklin School of North Orange." Building started in May. Located on Dodd Street, near Girard Avenue, the initial cost was $233.93. The planned second floor was not completed until 1833, and was then used for church purposes.

The Eastern District, encompassing basically all of the land east of Cherry Street (Arlington Avenue), was serviced by the Eastern School. A two-story schoolhouse was constructed on the south side of Main Street opposite Maple Avenue. This building was possibly constructed in 1835. One of the early teachers there, during the Civil War, was naturalist John Burroughs.

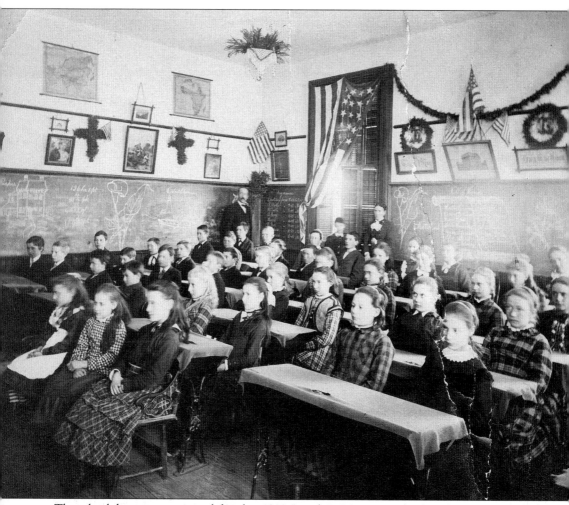

The school districts were consolidated in 1889. Joseph L. Munn was the first chairman. Vernon L. Davey, principal of Eastern School, was elected superintendent in 1890. Born in 1852, Davey worked tirelessly to improve the East Orange school system until a year before his death in 1914. He has been called "the Founder and Builder of the public school system of East Orange." Davey's first endeavor was to build a central high school. At that time, high school classes were taught in the Ashland, Eastern, and Franklin districts. Colleges came to East Orange in the 20th century. Upsala, Panzer, and Drake all called East Orange their home. So did the Berkeley School and Baptist Seminary. This is the oldest known East Orange school photograph in existence. It was taken in 1876 for display at the Centennial Celebration at Philadelphia. Shown here is the seventh-grade class of the Ashland School located on North Clinton Street. The teacher, standing in the back center, is Hattie Condit. The gentleman standing in the rear is the principal, Elias Raymond Pennoyer. Elias, the grandfather of Adm. Frederick Pennoyer Jr., died in 1891 and is buried in Rosedale Cemetery.

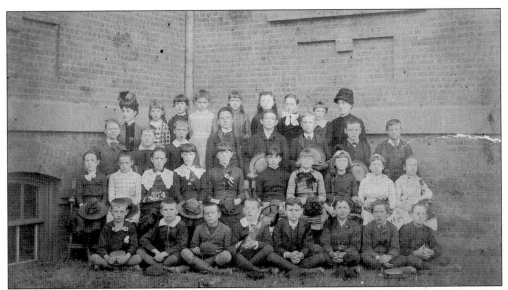

The Eastern School moved across Main Street to the north side in 1871. Still located near Maple Avenue, the new building was made of brick and built on a 200-foot-by-194-foot lot. The building was dedicated on September 4, 1871. This photograph shows the graduating class of either 1884 or 1885. The two women are not identified, but may be Mary D. Baldwin and Georgianna Stevenson, who taught in both the old and new school.

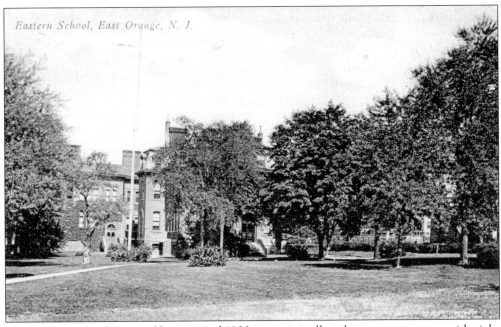

Eastern School, East Orange, N. J.

The Eastern School, pictured here around 1900, was originally a three-story structure with eight classrooms and a third-floor auditorium. That auditorium was later divided into four sections and used as a high school. An addition of eight rooms, seen on the left, was built in 1896. The auditorium was removed in 1936. Famous graduates of the school include Zane Grey, Adm. Raymond Spruance, and Adm. Frederick Pennoyer.

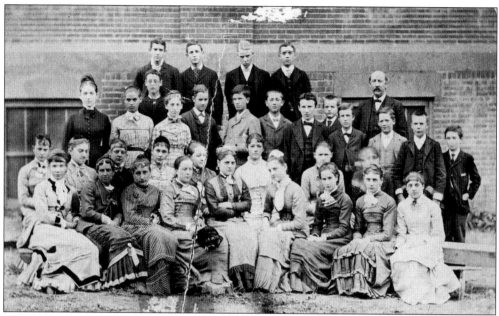

The Ashland School moved to Mulberry Street (North Clinton Street) and was dedicated on September 5, 1871. It included 10 classrooms and a third-floor assembly hall, which was later used for high school classes. Four additional rooms were added in 1885. Shown here, in front of the 1871 building, is the graduating class of 1880. Principal Elias R. Pennoyer is standing in the back row on the far right. The woman at the far left may be eighth-grade teacher Emma L Codey.

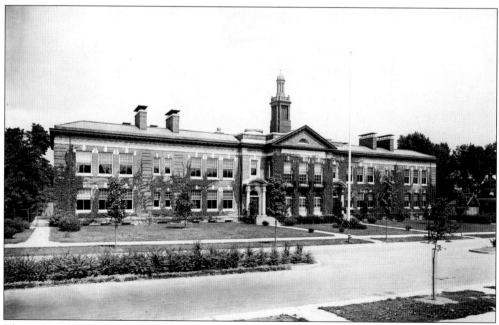

The Ashland School of 1871 was sold and became Our Lady Help of Christians grammar school in 1906. A new school was constructed on the north side of Park Avenue near North Clinton Street. It opened on January 7, 1907. The building held 18 classrooms, a large auditorium, and other rooms. The cost was $160,000. This photograph was taken in 1913.

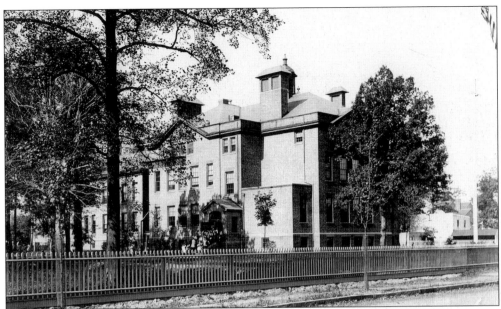

Elmwood School was originally called South Ashland School and was opened in 1887. Located on South Clinton Street near Elmwood Avenue, the original building held four classrooms. Eight more classrooms were added in 1890. In 1902, another six classrooms and a third-floor auditorium were added. In 1917, an addition of 16 rooms, a gymnasium, a shop, and a household unit was constructed. The photograph is dated 1913.

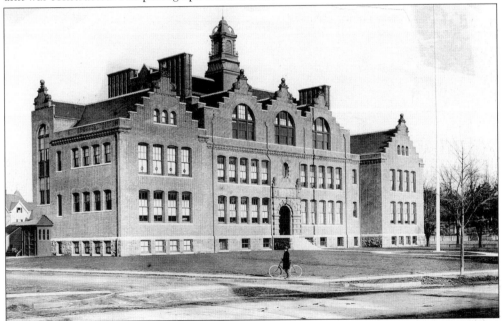

Nassau School was built on the north side of Central Avenue at the corner of South Arlington Avenue and opened on February 20, 1899. It immediately took students from Ashland, which was overflowing. The building had 12 classrooms. It is shown here in 1913 with its 1909 addition. Additions were made again in 1927, and a library was added in 1934. The school was named for William of Orange, count of Nassau.

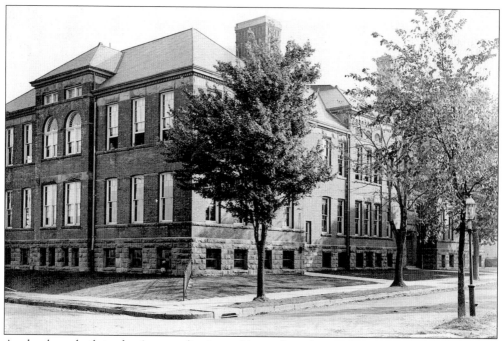

A school was built in the Ampere district and located on the southeast corner of Grove Street and Springdale Avenue. Built on farmland purchased from George Booth, it was named Columbian in honor of the 400th anniversary of the discovery of America by Christopher Columbus. Occupied in the spring of 1893, the original building held eight rooms. The school is shown here in 1913 featuring the new addition made that same year.

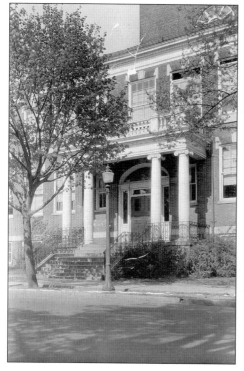

On February 13, 1905, the newly constructed Stockton School opened. Named for Richard Stockton, a New Jersey signer of the Declaration of Independence, the school was located on William Street between Greenwood Avenue and Nineteenth Street. The building contained 12 classrooms, a third-floor auditorium, and several other rooms. This photograph, showing the Greenwood Avenue entrance, is undated.

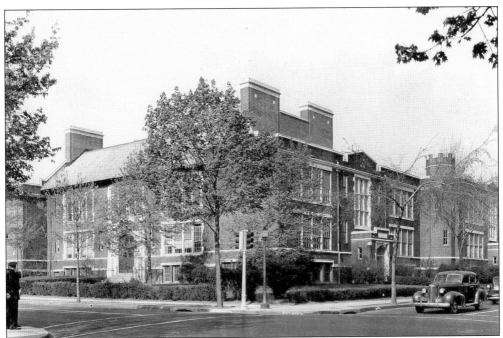

Pictured around 1950, the Washington School was opened in February 1912 on the corner of Sanford Street and Kenwood Place. It was named in honor of George Washington by the Orange Chapter, New Jersey Society, Sons of the American Revolution. Originally it had 12 classrooms. Eight more were added in 1920.

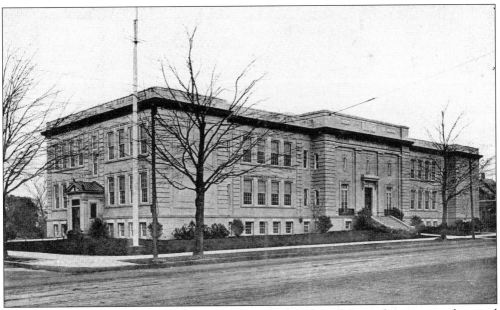

The Lincoln School was constructed on the corner of Maple and Central Avenues and opened in September 1908, but was dedicated on February 12, 1909, the 100th birthday of Abraham Lincoln. Originally there were six grades, but by 1911, there were eight. An addition in 1914 brought the total number of classrooms to 13. This photograph was taken around 1915.

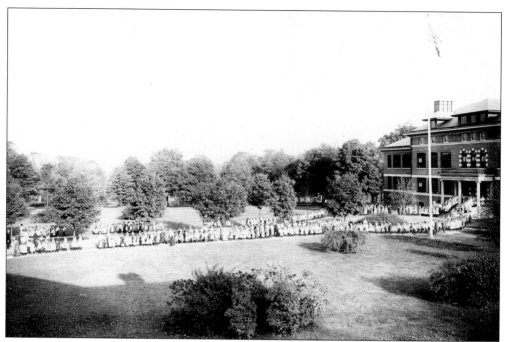

A new Franklin School was erected on the south side of Dodd Street, west of Glenwood Avenue, and dedicated on April 24, 1874. Made of brick, the lot was purchased from Josiah Dodd. There were originally four classrooms. Four more were added in 1884. Another addition was made in 1898. This photograph was taken in 1913.

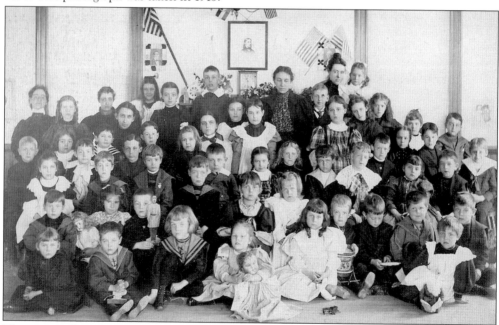

There were also private schools in East Orange. The caption on the back of this photograph reads, "Misses Adams School East Orange. Kindergarten Class. Taken April 25, 1893." In early East Orange public schools, kindergarten was not included. Notice the doll held by the girl on the left and the paper cutout of the Confederate soldier held by the boy.

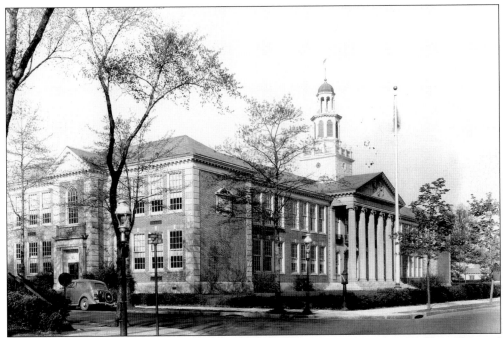

The Vernon L. Davey Junior High School was opened in September 1930. Built on Elmwood Avenue, it was encircled by Burnett Street, Rhode Island Avenue, and Eppirt Street. Davey was the first superintendent of the East Orange public schools. He was the first principal of East Orange High School. Davey retired in June 1913. He died on December 30, 1914.

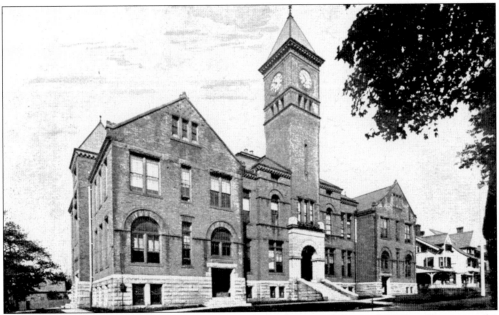

Land was purchased on the west side of Winans Street between Main and William Streets, and a high school building costing $120,000 was constructed. It held 10 classrooms, two study rooms, a chemical laboratory, a third-floor gymnasium, and a drawing room. Two basement rooms were later fitted for mechanical drawing and manual training. This photograph was taken around 1900.

47

As East Orange grew, as did the number of high school students, the demand for a bigger high school became apparent. The school lot was extended north to Walnut Street, and in September 1911, a new high school, connected to the old, opened its doors. The school included an auditorium that would seat 1,200. Additions were made in 1923 and 1960. The original building was torn down in 1958.

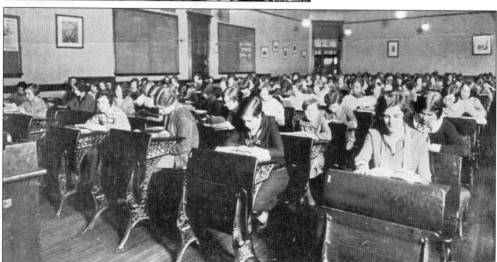

This *c.* 1927 photograph shows the girls' study hall, room 221. The conduct expected of the students was explained in the *Red and Blue Handbook*, and students not meeting the expectations were asked to leave. The school paper called the *News* started on October 13, 1899, and the yearbook was called *The Syllabus*. Members of the Quad and Quoin Club produced the school calendar. (AC.)

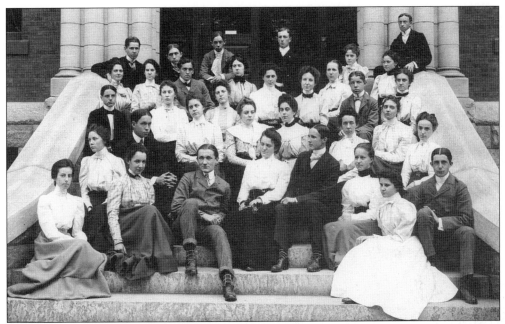

This is a photograph of the graduating class of 1899. There were four different courses of study: classical, Latin-English, English, and two-year commercial. The latter received certificates in lieu of diplomas. The graduating ceremony consisted of music, orations, and essays. This photograph was taken on the front entrance steps of the high school. The principal that year was Lincoln E. Rowley.

This "Brady Photo" is undated but was probably taken around 1900 on the front steps of the high school. The "club" is not disclosed, but may be a photograph of the Girl Reserves, a club opened to all classes and whose purpose was the "development of friendships, pleasant personalities, and good citizenship."

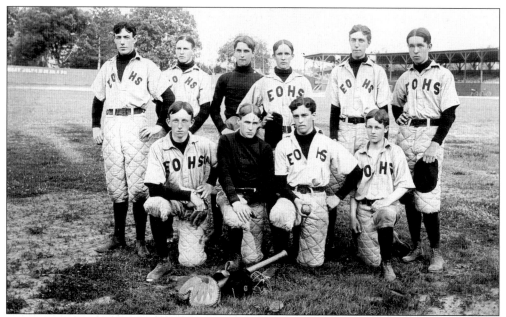

Seen here is the 1898 state championship baseball team. From left to right are (first row) William Underhill; Teddy Cassidy, short stop; Alfred Maine; and Charley Smith, third base; (second row) Morris Whinnery, catcher; Harold Condit; Edward Heale, second base; David S. Bingham; Richard Condit; and Harry Bingham, first base. This photograph may have been taken at the Orange Oval located on Eaton Place.

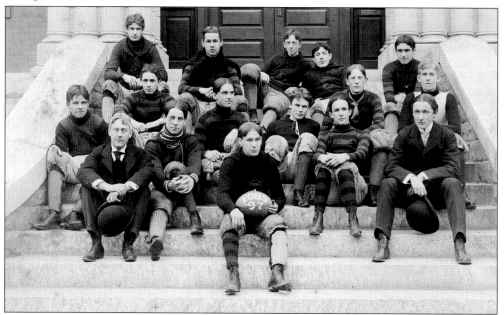

Shown here is the football team of 1898. From left to right are (first row) coach Adams, Arthur Whiteside, Fred Cassidy (captain and holding the football), Stuart Bingham, and Harold Cheney (team manager); (second row) Benard Daly, Howard Hill, Harry Duff, Ray Olin, Percy Smith, and Phelps Cowdon; (third row) George Cassidy, Fred Knollhoff, William Underhill, Morris Whinnery, and Arthur Muir.

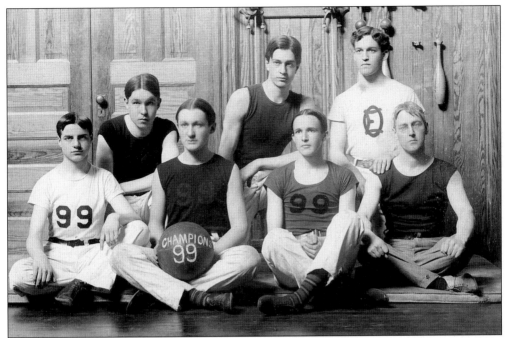

The same class won the state basketball championship in 1899. (The state football championship would be won by the class of 1900.) Shown here, probably in the third-floor gymnasium, are again some of the same boys. From left to right are ? Osborne, ? Brigham, ? Cheney, ? Bayles, David S. Bingham, Alfred Maine, and ? Adams.

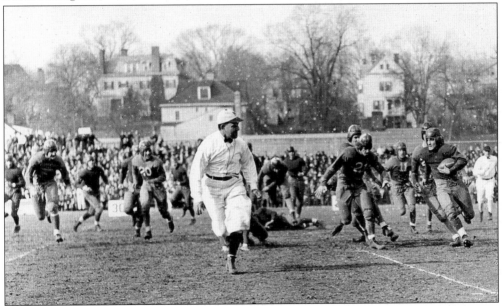

For many years, football was the mainstay of East Orange High School sports and of the city itself. The Ashland Stadium, completed in the 1920s, seated 8,000. There were many great rivalries, but none was bigger than the annual Thanksgiving Day game between East Orange and Barringer. Shown here, in an undated photograph, is Vic Amborsini of East Orange High School making a seven-yard end run gain against Barringer High School.

Clifford J. Scott High School, located on the corner of Renshaw Avenue and North Clinton Street, was built to help alleviate the overcrowding at East Orange High School. It was named for Clifford J. Scott, the superintendent of schools from 1921 to 1936. The school paper was the *Bagpipe*, and the yearbook the *Tartan*, in true "Scottie" tradition.

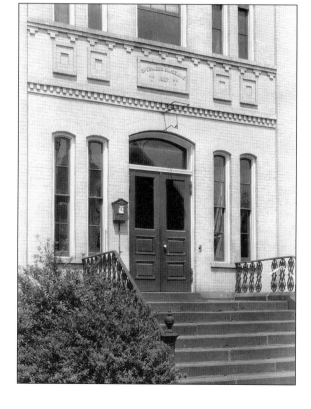

The first Catholic School in East Orange was Our Lady Help of Christians. Established in the spring of 1883, the classes were held in the church building at Main Street and Ashland Avenue. When the parish acquired the old Ashland School in 1906, it became the Our Lady Help of Christians grammar school.

The first Holy Name of Jesus School was established on North Park Street in 1910. The site was an old grocery and butcher shop. In 1927, a new church and school were built on Midland Avenue. The school housed about 16 classrooms. Other Catholic grammar schools in East Orange included St. Joseph's, not shown in this chapter.

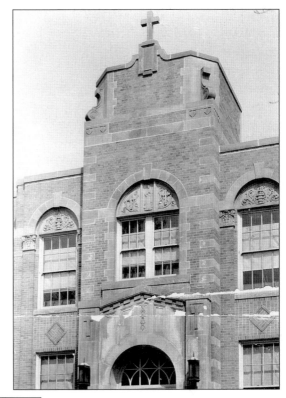

Our Lady of All Souls parish, established in 1914, did not have a school until 1928. At that time, a combination church and school was built on Fourth Avenue, east of Grove Street and across from Columbian Playground. The school, shown here, opened in September 1928, holding eight classrooms, an office, and a supply room. Kindergarten classes were held in the back of the cafeteria building located below the church.

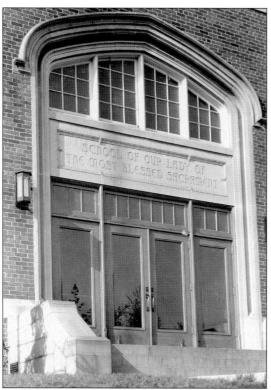

Our Lady of the Most Blessed Sacrament opened a grammar school in September 1922. Two years later they were hosting grades kindergarten through eight. Located on the southeast corner of Elmwood and Shepard Avenues, the school served the Roman Catholics of the Elmwood section.

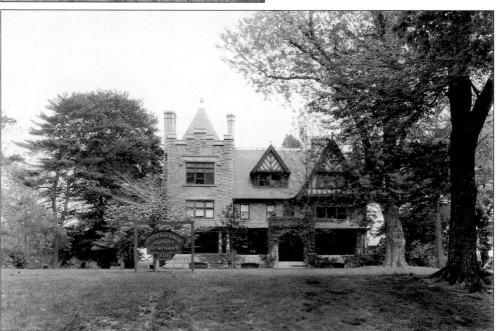

The estate of David S. Walton, known as the Beeches and located at 64 South Munn Avenue, was purchased and used to create the Baptist International Seminary. The completed seminary was dedicated on October 12, 1921. The land fronted about 300 feet on South Munn Avenue and then extended back about 650 feet to Essex County Boulevard.

The Normal School of Physical Education moved to East Orange in 1926 and was renamed Panzer College in 1932. It was located on the west side of Glenwood, north of Park Avenue. The school became part of Montclair State College and relocated there in 1958. The property was purchased by the Archdiocese of Newark and with a few additions reopened as East Orange Catholic High School on September 12, 1958.

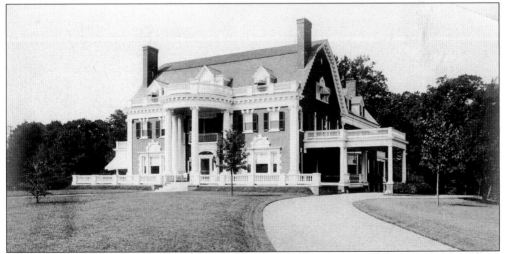

Founded in 1893, Upsala College moved to East Orange in 1924. A Swedish Lutheran School, Upsala acquired the property of Peter Hauck Jr., previously the Charles Hathaway mansion, shown here, as well as the William Thayer Brown mansion, both on Prospect Street north of Springdale Avenue. The Hathaway home became the girl's dormitory, and the Brown mansion became Old Main.

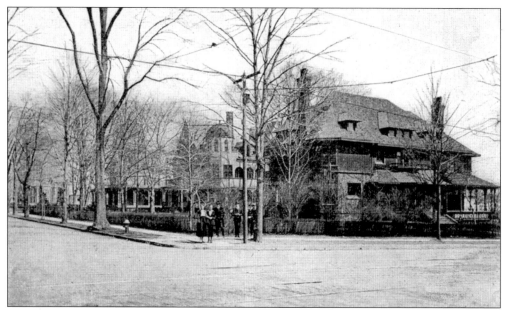

Drake College was located on the northwest corner of Harrison Street and Central Avenue. It opened around 1910. It was a business school that offered courses in banking, finance, shorthand, bookkeeping, typewriting, English, civil service, mechanical drawing, and secretarial skills. To the right is Harrison Street, and to the left is Central Avenue.

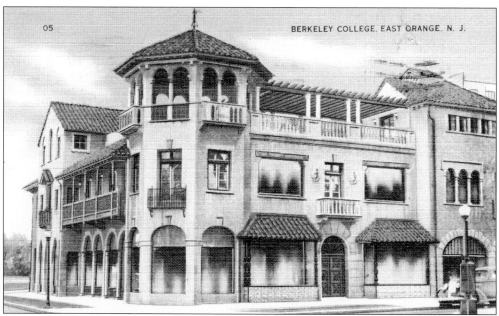

The Berkeley School was founded in 1931 and named for Lord John Berkeley. It occupied the third floor of the Dane Building, which is shown here. Built in 1930 on the southeast corner of Prospect Street (right) and William Street (left), the Dane Building housed the beautiful Blue Door boutique. Berkeley educated young men and women in business and secretarial skills. The school relocated in 1976.

Five

CHURCHES AND TEMPLES

The Newark colony was founded as a theocracy. Therefore it is no surprise that religion played a large role in the formation of the society that would become Essex County. The Mountain Society people, a little more removed from the meetinghouse than the people of Newark, may have been a bit more liberal in their religious outlook but were quite pious nonetheless.

The formation of a second meetinghouse in Orange, what would become the First Presbyterian church, was probably the beginning of the schism that would lead to separation in 1806.

The first church built in East Orange was the Second Presbyterian Church, which would become better known as Brick Church. Over the years, more and more churches would be built and more and more denominations recognized. At its peak, the three-and-nine-tenths-square-mile city of East Orange would have 47 churches and a dozen denominations.

Religion also played a large part in the education process. The building of public schools was often approved on the argument that the space could be used for Sunday school as well. The appearance of Catholic churches led to the building of five Catholic grammar schools and one Catholic high school in the city. The International Baptist Seminary as well as Upsala College were constructed under the auspices of religious groups.

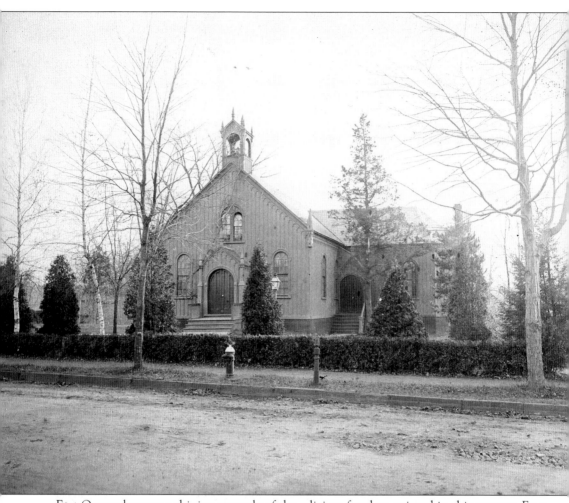

East Orange became a shining example of the religious freedom enjoyed in this country. From the Church of Latter Day Saints to the Jewish temple, from the original Presbyterian settlers to the newly arriving Roman Catholics, the city tolerated and welcomed all faiths and continues to do so today. Unfortunately, there is not room to show all of the East Orange churches that have existed throughout the years, but as many as possible are shown in this chapter. The photographs here provide a flavor for the type of beautiful structures for which the city became known. Bethel Presbyterian Church had its beginnings on September 13, 1817, in the home of Calvin Dodd. The result of that meeting was the start of a Sunday school in a small copper shop near Dodd Street and Midland Avenue. Classes were later moved to the Franklin school. The chapel shown here was erected on the south side of Dodd Street near Brighton Avenue in 1866. The church remained there until 1891, when a stone structure was erected on the northwest corner of Dodd Street and Midland Avenue.

At a meeting held on March 20, 1830, the need for a second Presbyterian church in Orange was agreed upon. Land was acquired on the northwest corner of Main and Prospect Streets, and a church was constructed out of brick. The nickname Brick Church was soon applied, and eventually that became the name of that entire section of town. Expansions were made in 1878 and 1907. This photograph was taken about 1938.

The First Baptist Church of the Oranges was formed in 1837, but the edifice built at Maple Avenue and Church Place, shown here, was not completed until 1858. In April 1892, the congregation erected a new church on Main Street and Hawthorne Avenue and this structure became the Calvary Colored Baptist Church, whose members had been meeting in the basement of the old Calvary Methodist Church on North Clinton Street. This photograph was taken around 1890.

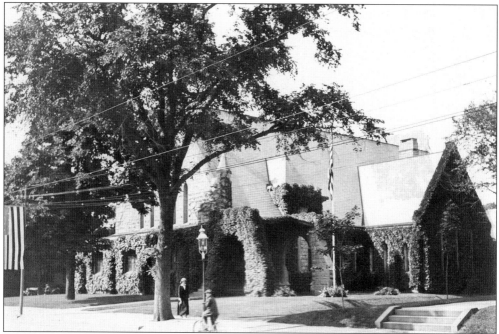

Christ Episcopal Church was built on the northeast corner of Main and North Clinton Streets in December 1870. The congregation had been formed two years earlier when 20 people met in the East Orange Railroad Station on September 15, 1868. The first edifice had several additions before it burned on December 23, 1888. A new building, shown here in this 1913 photograph, held its first service on Easter Sunday, March 29, 1891.

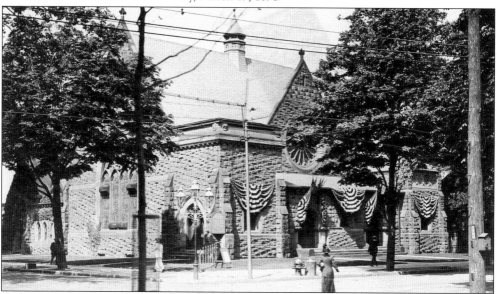

The Grove Street First Congregational Church, shown in this 1913 photograph and decorated with bunting for the city's 50th anniversary celebration, was built on the east side of Grove Street north of Main Street in the fall of 1867. It was dedicated on December 13 of that year. New additions were made in 1871 and in 1888. An auditorium was added in 1890. The church burned on December 28, 1952.

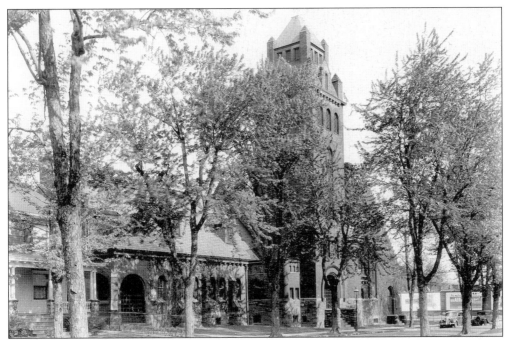

The Hawthorne Avenue Baptist Church was constructed in 1892 on the corner of Main Street and Hawthorne Avenue. Shown here in this c. 1938 photograph, its cornerstone was laid in July 1891. Additional land on Oraton Parkway and Main Street was acquired in 1921. An addition to the church building was completed on that land in 1930 and dedicated that same year.

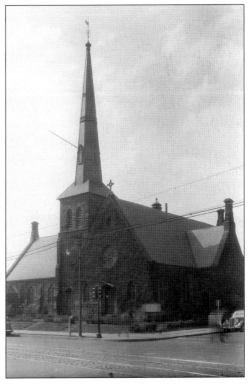

The First Dutch Reformed Church was the result of a schism in the Brick Presbyterian Church. About 130 members of the latter church broke away, and on May 12, 1875, formally organized their new church. A new edifice was started on the corner of Main and North Harrison Streets and completed in 1875. Nicknamed "the Brownstone Church," it was built at a cost of just over $30,000. An addition was later built on the south side.

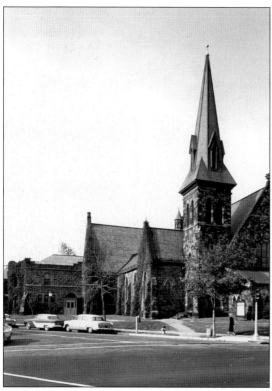

The First Presbyterian Church, more often referred to as the "Munn Avenue Presbyterian Church" was organized in June 1863. The church was built on the southwest corner of South Munn Avenue and Main Street and dedicated on July 21, 1864. Additions to both sides of the church were made in 1876, and in 1888, the main auditorium was enlarged. The Andrew Reasoner Memorial Chapel, far left, was added and dedicated on September 28, 1902. This picture was taken around 1955.

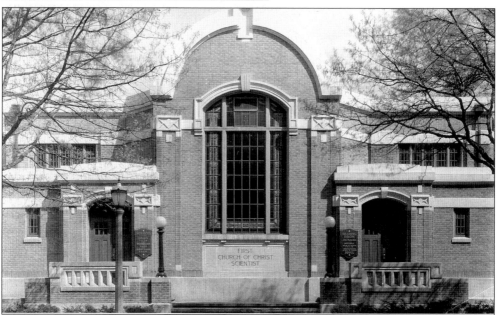

First Church of Christ Scientist was organized in East Orange on September 28, 1910. A state charter of incorporation was received on December 29 of the same year. The group had at least four different meeting places before this building was constructed on the west side of North Oraton Parkway, just north of William Street. A larger church edifice was completed in 1926 at this same site.

Originally the Hyde Park Clubhouse, located at the corner of Wilcox Place and Whittlesey Avenue, this building later became the chapel of the Hyde Park Reformed Church on April 16, 1904. It was purchased in 1932 by the Church of Latter Day Saints. Renovated to be used as a meeting place, it became the main edifice for its members in the northern New Jersey and lower New York area.

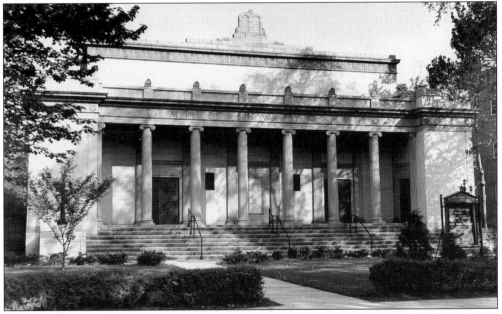

Temple Sharey Tefilo was erected on the west side of Prospect Street just north of Main Street in East Orange and dedicated on April 22, 1927, but its origins go back to 1874. At that time, 11 men organized Congregation Sharey Tefilo to serve the small Jewish population of the Oranges. A temple was built on Cleveland Street in Orange in 1895 and served until Temple Sharey Tefilo was erected to serve the growing community.

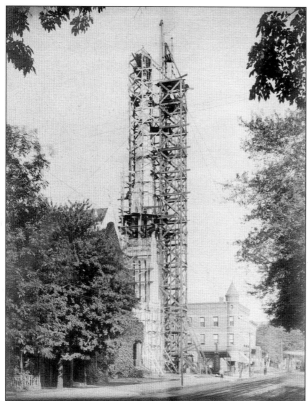

Our Lady Help of Christians, the Mother Church of the Catholic parishes in East Orange, was founded in the spring of 1882. A lot was purchased on the north side of Main Street near North Clinton Street, and a small structure was built. The main church building, shown here, was started about 10 years later, but the well-known spire was not finished until years later. This photograph was taken around 1907.

This house, located on Rutledge Avenue and purchased on January 3, 1910, served as a mission chapel of Our Lady Help of Christians called Our Lady of All Souls. When the back of the house was extended it was nicknamed "the Bowling Alley Chapel." The first pastor, John J. Murphy, purchased land on the southeast corner of Fourth Avenue and Grove Streets. A church and school was built there in 1927.

Six

AROUND TOWN

At the height of its population, which was about 90,000, East Orange was also capable of providing its residents with virtually all of their needs. Main Street and Central Avenue were shopping meccas, with a plethora of small shops and a number of large department stores. The Doddtown and Ampere sections also had small shopping centers, which serviced the local needs. In fact, Ampere—with its library, post office, banks, theater, train station, pharmacies, and restaurants—could almost have operated as a separate town.

Main Street was a shopping area almost from its inception. While there were many houses there in the early days, it also became the location of dry goods stores, grocers, carpenters, wheelwrights, wagon makers, and many other trades. Over time, the homes disappeared, and by the 1920s, the street contained almost nothing but stores and churches. Muirs Department store, located on the northeast corner or Main and Prospect Streets, was the anchor.

Central Avenue also became a shopping district and, in terms of high-end stores, surpassed Main Street. However, this transition from homes and estates to shops and department stores was not nearly so smooth. At the beginning of the 20th century, Main Street had a trolley line. Certain citizens of Newark and the Oranges wanted trolley lines on Central and Park Avenues as well. Others wanted the streets kept more bucolic in nature. The trolley was bitterly fought, but the measure passed. Central Avenue quickly filled up with shops and stores. It would soon be the repository of New York City's B. Altman, making East Orange the first suburb to be so honored and leading to the nickname "the Fifth Avenue of the Suburbs."

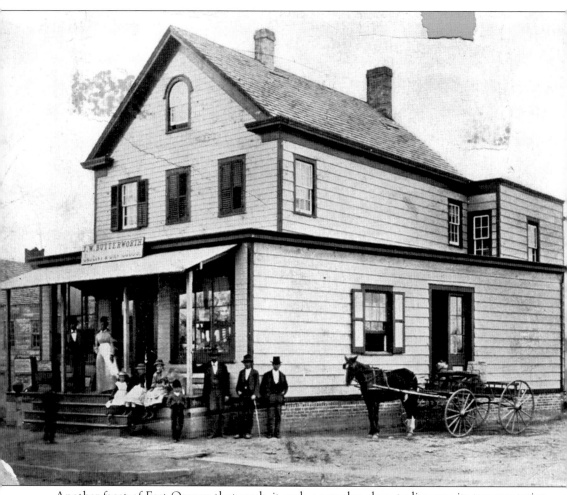

Another facet of East Orange that made it such a popular place to live was its transportation system. The city had three trolley lines: Main Street, Central Avenue, and Dodd/Prospect Street. The city also had three train lines. The Erie Lackawanna line, which ran along Main Street, had three stations. The Erie line running through Ampere had one station. The Greenwood Lake Division, which ran through Doddtown, had stations at Prospect Street and Brighton Avenue. With six train stations and three trolley lines, plus three main thoroughfares, East Orange was easily connected to the job markets in Newark and New York City. Cross-town traffic was less enabled, with Essex County Boulevard (which later became the Garden State Parkway) as the main road. The Joseph Wood Butterworth store was located on the northwest corner of Dodd and Prospect Streets. This photograph is undated, but family records indicate it was taken prior to 1872, and the store was probably built around 1858. Joseph Wood Butterworth was born in 1832 in England and died in 1915 at his Dodd Street home. He may be the man at the far left leaning against the post. Doddtown was always like a village within East Orange, with its own shops and tradesmen. (Courtesy East Orange Public Library and Condit/Henry families.)

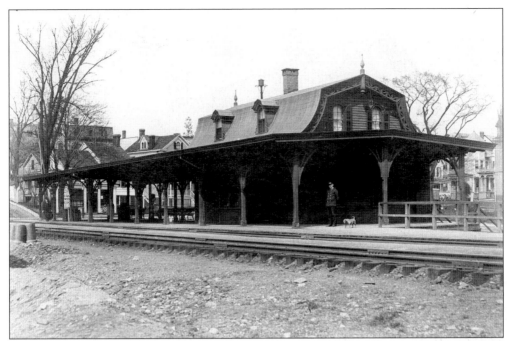

The Morris and Essex Railroad established a train line through East Orange on November 19, 1836. Originally the cars were horse drawn, but were changed to steam two years later. This c. 1885 photograph shows the Grove Street Station, which was called the East Orange Station until the 1890s. The construction date is unknown, but it does appear on an 1879 map. It was replaced by a brick structure in 1903.

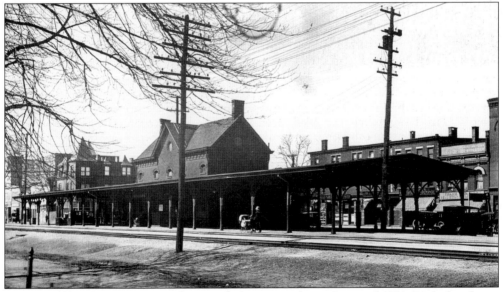

The Brick Church Station is seen here just before it was elevated, around 1920. Brick church was the first train stop in East Orange, and the first train station was donated in 1864 by Matthais Halsted. A second station was built in 1880. The third station was built in 1922 when the tracks were elevated. Electrification came on September 22, 1930. The building just visible on the far right is the Essex Hotel.

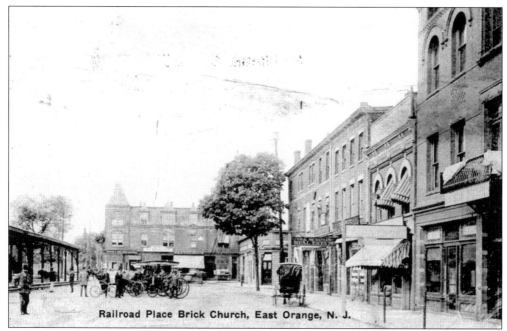

Railroad Place Brick Church, East Orange, N. J.

A back view of Brick Church Station at Railroad Place is seen here, around 1900. This view looks west. Unseen on the left is the station. The building on the far right is the Essex Hotel. To the left of the awning is a sign reading, "Ira M. Taylor Real Estate Insurance & Loans." The Morris and Essex Railroad was eventually purchased by the Delaware, Lackawanna and Western (DL&W) Railroad.

This 1921 photograph looks east on Main Street from Winans Street. The railroad tracks run off to the left and to the East Orange Station. Originally know as Junction, a station was constructed in 1883, although earlier maps do show a wooden structure. A new station was built in 1922 when the tracks were elevated. In the center of the photograph is the K. L. McCloskey Company Real Estate office, to the far right is S. Longo's "Hygenic Barber Shop."

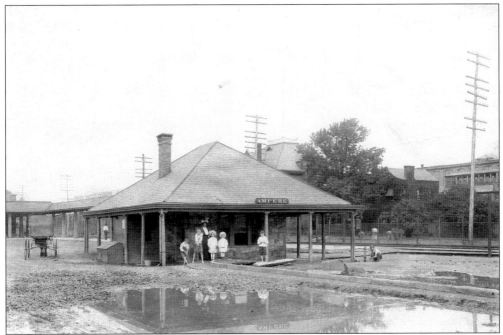

Originally a flag stop called the Crescent, the DL&W Montclair Branch, which began running through East Orange on July 1, 1856, built a station in the Ampere Section after Crocker-Wheeler opened a plant there in 1893. This fieldstone station was built in the early 1890s. A second station was built in 1908. That was replaced in 1922 when the tracks were elevated. This photograph was taken around 1900.

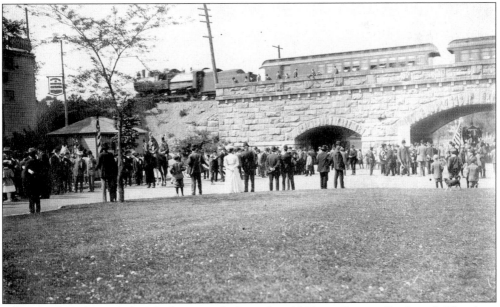

This photograph was taken looking north from the old Essex County Boulevard. The dress seems to indicate it was taken around 1900, and the purpose appears to be a celebration of the opening of the boulevard, but the photograph is unmarked. While the DL&W train tracks were not elevated until 1922, certain roads did not have grade crossings and passed under the tracks.

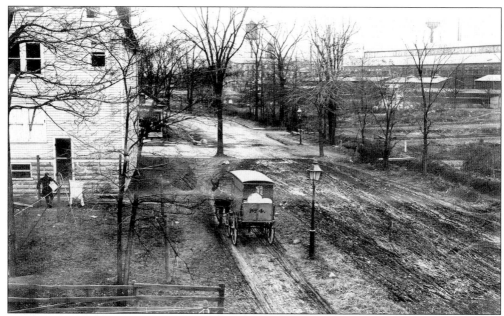

This December 5, 1911, photograph was taken looking northwest on Lawrence Street between Marcy Avenue and Norman Street. The wagon, marked simply "No. 4" appears to be a delivery truck as a man is carrying a package to the house on the left. Off to the right is the A. P. Smith Manufacturing Company and to the left of that the Sprague Electric Company. A. P. Smith manufactured valve fittings and water work supplies.

Not every old-time job was glamorous. Shown here is garbage collection taking place on North Arlington Avenue between Park and Springdale Avenues. The wagon says "Michael Loprete Contractor East Orange." The photograph is undated, but appears to be around 1900. Loprete's business was at 45 Harrison Street, and he lived on Amherst Street.

The man shown here is picking up trash on Main Street. Looking west, on the right the East Orange Delicatessen can be seen, followed by a store, barbershop, and city hall. In the center of the photograph one can see the Orange trolley line. Again the photograph is undated, but seems to have been taken around 1900, since the old city hall exists, but no automobiles are in sight.

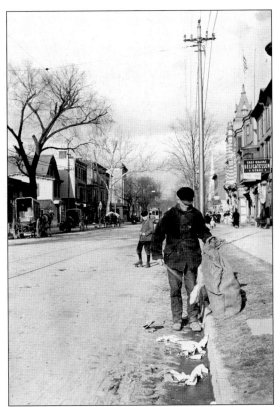

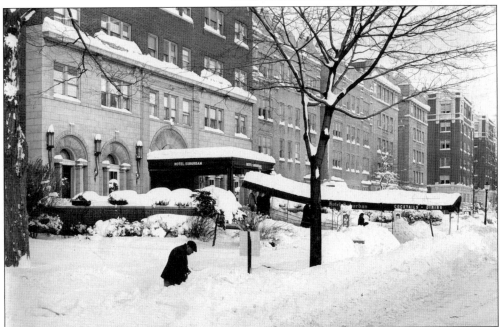

This man with the coal shovel is facing a daunting task. This photograph was taken on December 26, 1947, after the big blizzard that paralyzed East Orange and the whole metropolitan area. The view looks north along Harrison Street past the top-rated Hotel Suburban.

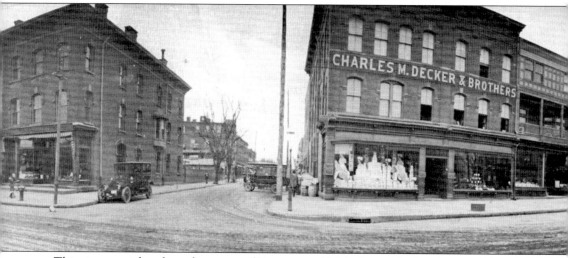

This view was taken from the corner of Prospect and Main Streets looking west up Main Street. Although undated, it may have been taken in 1913 for the 50th anniversary of East Orange. Near the center of the photograph is the Charles M. Decker and Brothers dry goods store. The street to the left of that is Washington Place. The center street is Main Street. To the right is

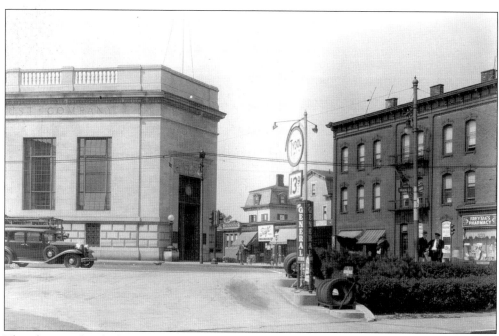

This photograph, which appears to have been taken in the late 1930s, looks south from the North Arlington Avenue across Main Street. The building to the left is the Essex County Trust Company. To the right is a Tydol service station selling General Tires and gasoline for 13.9¢ a gallon. To the far right is Freytag's Pharmacy. Across Main Street, in the center, is a store called Taft.

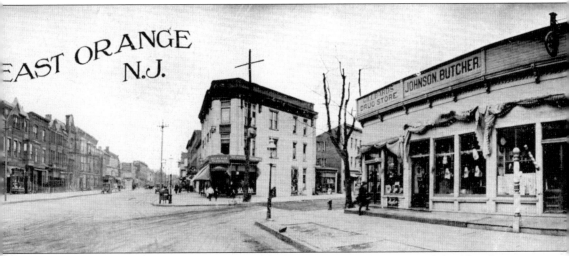

Washington Street. Looking up Main Street, which was nicknamed "Avenue of the Churches," Pursell Caterers is visible on the left side (next to the first vehicle). The cross-street just beyond that is Harrison Street. The building to the right center housed the Albert Heineman Pharmacy. On the right are Gillbard's Drug Store and Johnson Butcher.

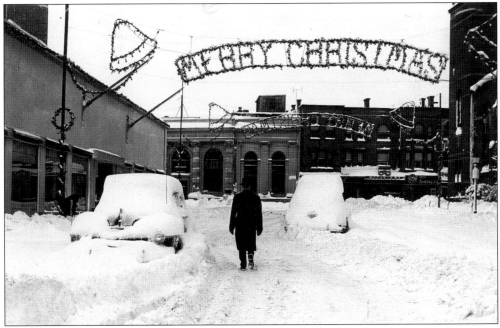

When large snowstorms came, they were crippling. Yet East Orange fared better than many surrounding towns, as they had started placed their electrical wires underground in the 19th century. This photograph of the 1947 "Christmas Blizzard" was taken on December 26. The view is from Prospect Street looking south toward Main Street. The building to the left is Muirs. To the right is Brick Church.

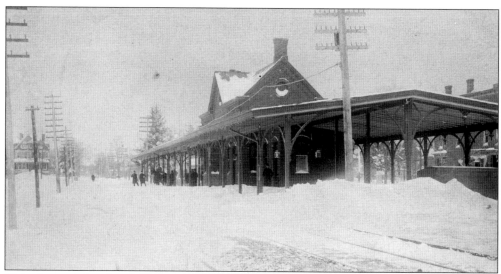

This photograph is dated on the back as Old Brick Church Station 1880, but the author wonders if it might have been taken on March 12, 1888, a day after the Blizzard of 1888, when trains on the DL&W line were stalled by the huge snow drifts. In spite of the storm on March 11, the election scheduled that day was held. By the end of the day, horses could not make it through the drifts and virtually all traffic was stopped.

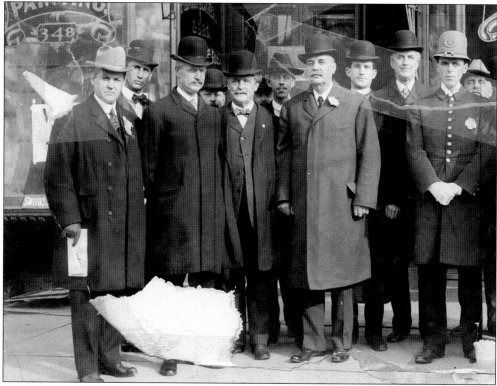

This photograph appears to have been taken in front of 348 Main Street. It seems to be a grand opening of some sort and may be the opening of Starbuck and Yeager, which was located there around 1905. The policeman is wearing badge No. 10.

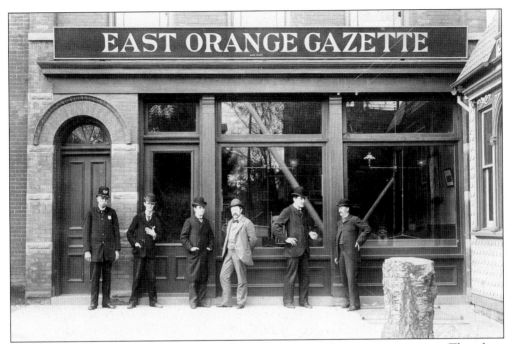

The *East Orange Gazette* was established in 1873. The weekly paper came out on Thursdays. This photograph was taken in 1895. The location may have been at 16 Washington Place, which later became the offices of the *East Orange Record*, and which is still the local paper today.

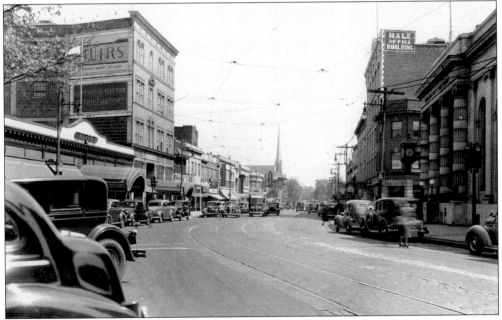

This 1938 photograph looks east down Main Street. On the left is Muirs Department Store. In the left center of the photograph the marquee of the Ormont theater can barely be seen. To the right of that is the spire of Our Lady Help of Christians Church. On the right side of the street is the Hale Building, where *Nancy Drew* and other books were published. The columned building is the Savings Investment and Trust Company.

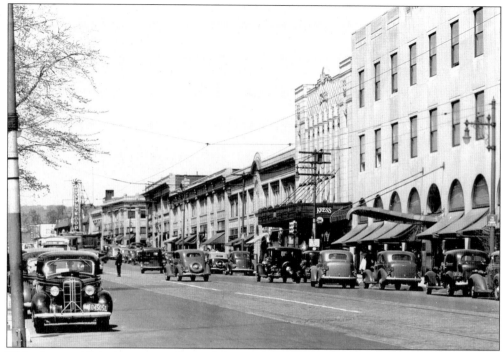

This photograph looks west up Central Avenue. On the right is the famous B. Altman and Company Department Store. The New York City store came to East Orange in March 1931. East Orange became one of the premiere shopping locations in the region, and Central Avenue became the "Fifth Avenue of the Suburbs." On the far left, on the right side of the street, is the marquee of the Hollywood Theater.

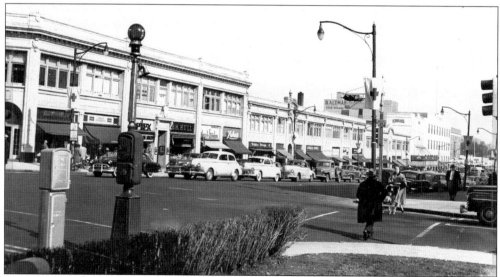

This c. 1950 view of Central Avenue looks east toward Newark. The cross street is South Harrison. B. Altman's is the large, white building on the far right of the photograph. To the left of that is Kress. Other name stores found on Central Avenue included Black, Starr and Gorman, as well as Wiss and Son. Still other Central Avenue stores included Franklin-Simon, Peck and Peck, McCutcheon's, and Stuart-Gordon.

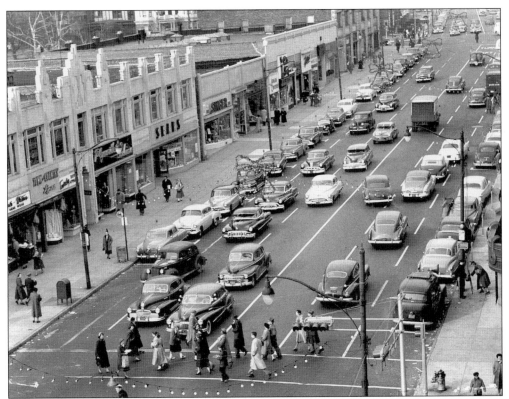

This Christmastime view, looking west, may have been taken in 1950 from atop the B. Altman building. On the left side of the street, Sears and Singer are both visible. The cross street at the bottom is Sanford and at the top South Harrison. Children of the 1940s, 1950s, and 1960s will remember more vividly F. W. Woolworth's, East Orange Toy Shop, Lofts Candy, and L. E. Yeagar Stationery, all located on Main Street.

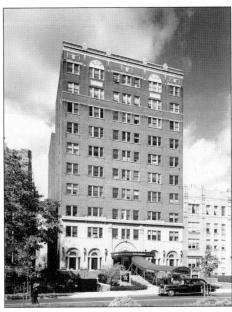

East Orange had several fine hotels. The most famous of these was the Suburban. Located on South Harrison Street, the hotel sported the famous Paris-in-the-Sky Restaurant, with its Sidewalk Café that overlooked New York City, and luxurious Left Bank Room that included dancing. Other dining facilities included the Crystal Room, Rose Room, and Mimosa Room. The hotel was the headquarters of the world premiere of *Edison the Man*, starring Spencer Tracy.

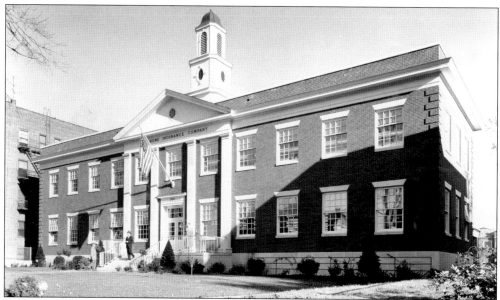

East Orange was once home to about 50 different insurance companies, thanks largely to the efforts of Frank H. Taylor and Son Real Estate. Taylor was also responsible for enticing the "name" Central Avenue department stores to move to the city. The firm also brought Bell Telephone Company to town. Shown around 1960 is the Home Insurance Company. Firms such as these could be found throughout the city.

This photograph is of the American Casualty Company, another of the large insurance companies to call East Orange home. Although the location is not provided, this c. 1960 photograph provides a rare view of one of the apartment buildings typical of East Orange. Unlike other towns, East Orange had no height restrictions on apartments buildings, so many of them were quite high.

Seven

OLD HOUSES

The first homes built in East Orange were simple farmhouses. Most of the original settlers could afford little else in either money or time. Over time, as money and time could be invested in luxuries, the homes in East Orange became more elaborate. As mentioned already, the Halsted house built on Main Street in 1840 became a model sales piece. Later in the century, East Orange attracted wealthy individuals who bought large parcels of land and built estates on them. Some of them were even given names. On Prospect Street the Lohrke Estate was called Trunheim, while the Brown Estate was Long Meadow. Munn Avenue had the Walton and Hill Estates called the Beeches and Hillcrest respectively. On Harrison Street the Nevis Estate was Hollywood Hall. Some homes had names, too, like the home of William Hiss at 44 South Munn Avenue called the House of the White Lions.

With the Victorian Era came Victorian homes, and these soon crowded the more elegant streets such as Harrison, Prospect, Glenwood, and Munn Streets. But they could be found on many other streets throughout the city and can still be found today. Tudors and Queen Annes lined the avenues with their elaborate turrets looking out at the growing population.

Eventually these estate and large home owners began to sell their land to apartment developers. It was not long before East Orange began to reach for the sky. Although the first apartment dates to 1911, and many were built between 1910 and 1920, the real apartment boom began in the 1920s and continued for several decades.

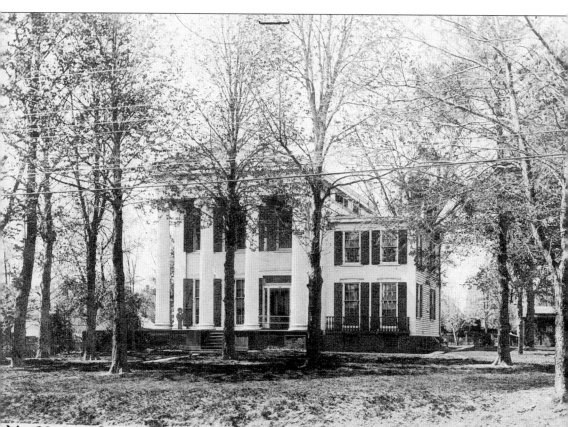

Matthias Ogden Halsted House - Main St. E.Orange. Built 1840

Before it began building luxury apartments and became a city of "cliff-dwellers," East Orange was know for its large estates, unique architecture, and luxurious Victorian houses. The house shown here, that of Matthais Ogden Halsted, located on Main Street and built around 1840, was largely responsible for the first real estate boom. Halsted enticed his friends to buy plots from him and move to East Orange, but his main selling point was his own Corinthian columned home. The apartment buildings that replaced these estates were not what people know today. They were elaborate edifices with doormen, restaurants, pools, and other amenities. Consider 75 Prospect Street. This apartment building, actually a cooperative, offered apartments up to eight rooms in size with four baths. At 32 South Munn Avenue, residents found a gymnasium, card room, ballroom, and solarium on the roof. At 67 South Munn Avenue, they offered up to 15 rooms and five baths as well as two houses for sale—built on the roof! At the time, 1928, it was the largest apartment building in New Jersey. East Orange became a haven for renters and homeowners alike, a bedroom community with luxurious parks, beautiful streets, magnificent buildings, fine government, top-notch police and fire departments, and the finest schools. Many polls concluded there were few better places to live in the nation.

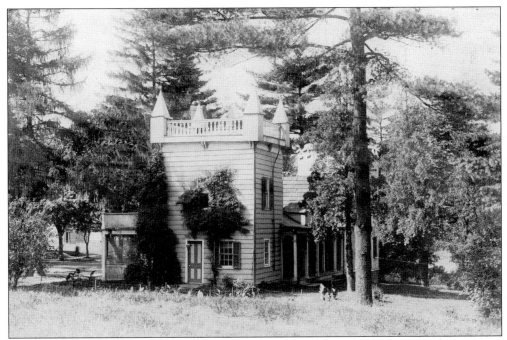

The Soverel family, mentioned earlier, left its legacy in Soverel Park. This was their Springdale Avenue home as seen on Columbus Day in 1907. The original structure was built around 1757. It was altered in 1840, 1864, and 1870, around which time Matthias Soverel added the turrets and towers. This view looks at the east side of the home.

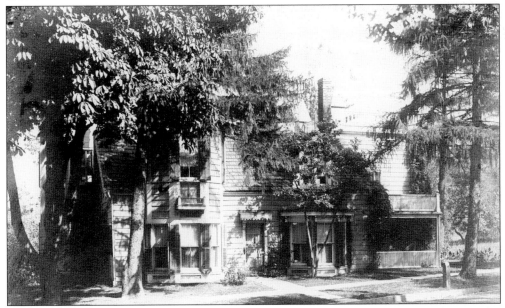

Here is another view of the Soverel house. For a time, the house was owned by John Wright, mentioned earlier as being wounded at the Battle of Peck's Hill. British and Hessian soldiers pillaged this house. They stole 18 geese, but spared the gander, leaving a pouch with 18 pennies around its neck and this poem: "Dear Mr. Wright, we bid you good night,/ It is time for us to wander./ We've bought your geese for a penny apiece,/ And left the pay with the gander."

This is the Zebina Dodd homestead, erected around 1763, probably by David Dodd Sr. It originally stood on the north side of Dodd Street a bit west of Midland Avenue. It was torn down to make room for the Bethel Presbyterian Sunday School in 1905.

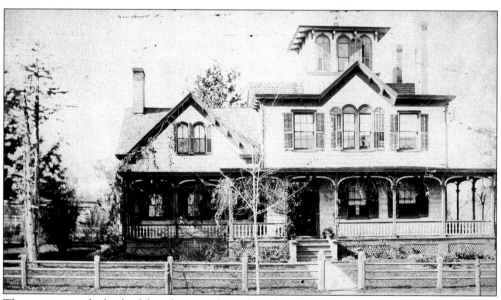

The caption on the back of this photograph reads, "The Dodd Homestead. Prospect Street. Over 100 years old. Home of Stephen Dodd." Although no address is provided, old maps do show a Stephen M. Dodd house located on the west side of Prospect Street at the tip of Marcy Avenue. This is probably the location.

This is the home of Calvin D. Pierson, located on the southeast corner of Main and Harrison Streets and taken in 1880. Although the Pierson name dates back to the founding of the Newark colony, no information could be found about this man. This view looks southeast. The front street is Main Street while the street off to the right is Harrison Street.

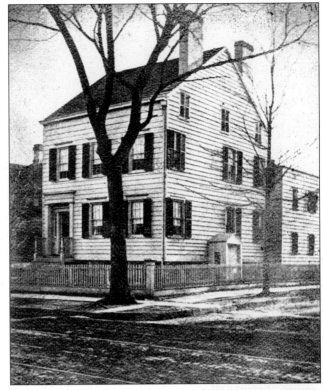

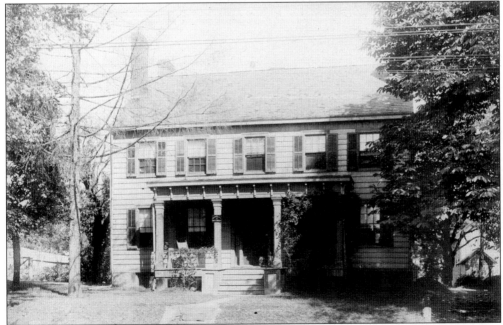

This house, located at 430 Main Street and photographed on October 9, 1907, was owned at the time by F. B. Boardman. Built on the north side of Main Street and west of Mulford Street (probably named for Timothy Mulford, who owned a wagon factory in town), the house was less than a block away from the location of the first town meeting.

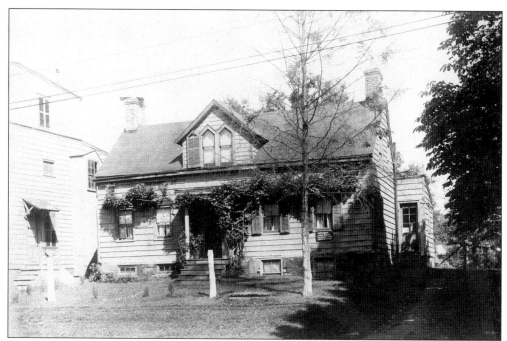

The caption reads that the house number was 438 Main Street, but the old maps indicated the lot as 436. It was owned at the time by Jno. English. Like the house shown in the previous photograph, this was also located on the north side of Main Street and west of Mulford Street. Mulford Street was later renamed North Burnett Street.

This house, located on the southwest corner of Burnett Street and the railroad tracks, was photographed on October 9, 1907. Old maps seem to indicate that the address was 5 Burnett Street and owned by the Hudson Realty Company at that time. The sign over the left entrance says, "Mrs. Wa . . . Employment Office.

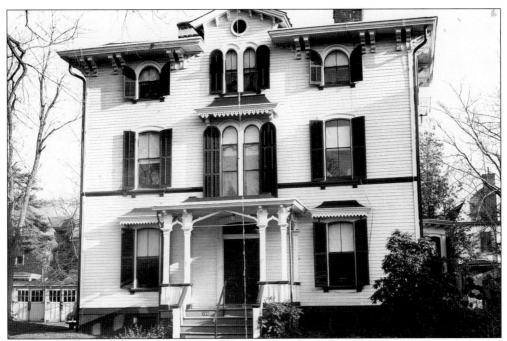

The caption on the back of this photograph reads, "Original owner Matthew Ogden. Lived in by his descendant – Ogden Halsted Bowers. Last owner. Died 1959. Torn down 1965. 106 Halsted Street." The photograph, from the look of the car on the left, appears to have been taken around 1950. The house was just south of the intersection of Halsted Place.

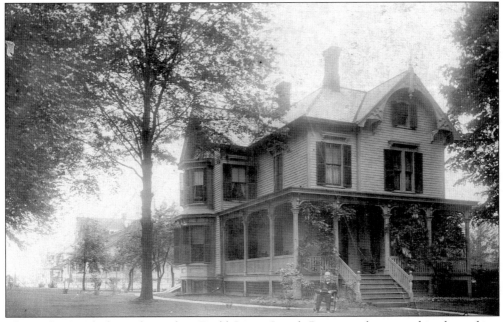

This is the Condit home located on Dodd Street. Joseph Butterworth is seated in the rocking chair. The exact location of the house is not known, but a Condit home is shown on old maps situated on the southeast corner of Dodd Street and Glenwood Avenue. (Courtesy of Kathleen and Geof Condit.)

This real estate photograph was taken around 1915. The location of the house is Brighton Avenue. The advertisement reads, "50 X 120. Fruit, flowers and shade. Dry cemented cellar with heater, laundry tubs and toilet. First floor three rooms and pantry. Second floor five rooms. Third floor two rooms. Gas fixtures, city water, sewer connection, . . . open fire place in dining room. Hardwood floor. $6,000." (Courtesy Glen Ridge Public Library.)

These two houses for sale were on Boyden Street. The advertisement read, "Lots 35 X 130. First floor four rooms and butler's pantry. Second floor four rooms and bath. Third floor one and one storeroom. Steam heat, gas fixtures, water, sewer connection, laundry tubs in cellar, cemented cellar, house 24 X 34. Near two stations and trolley. Price $5,200." (Courtesy Glen Ridge Public Library.)

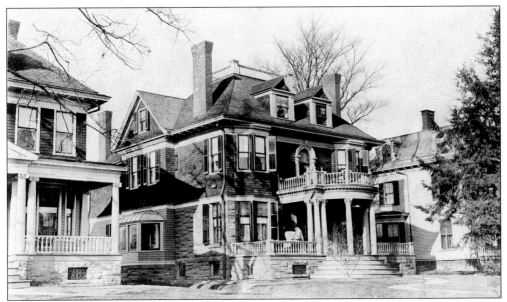

Another real estate photograph shows a beautiful Victorian house located on Glenwood Avenue. The advertisement read (in part), "Lot 55 X 443. First floor four rooms, butler's pantry and hall, including: salon parlor or living room with fireplace, reception hall with vestibule. Fireplace in library, conservatory with dining room separated by sliding doors. Hardwood floors. Two rear porches. Four bedrooms. . . . Upper porch. Third floor two finished rooms. . . . Price $17,500." (Courtesy Glen Ridge Public Library.)

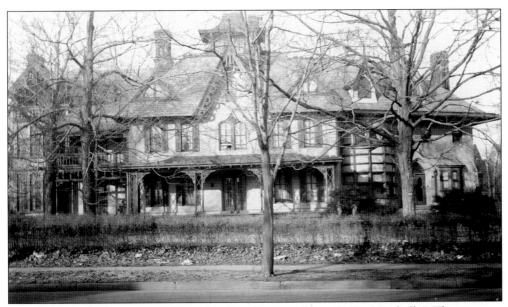

This photograph is captioned "Franklin Fort Property formerly Dr. Mitchells." The property fronted 339 feet on South Grove Street and went back 195 feet to Mitchell Place. It had a curved driveway in front and three outbuildings in the rear. Dr. Winthrop D. Mitchell and his wife lived in the house in the early part of the 20th century. On later maps the estate belongs to the Forts.

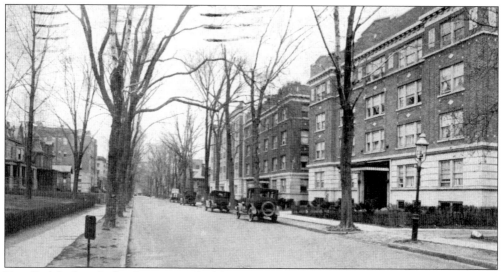

For all of the hundreds of apartment buildings in East Orange, few photographs or postcards of them exist. This postcard, looking north on North Arlington Avenue toward William Street, shows a row of apartment buildings in the mid-1920s. By the mid-1930s, East Orange had more apartment buildings than any other East Coast community.

There were a few factories in East Orange. The A. P. Smith Manufacturing Company was located between Lawrence Street and the Bloomfield border. They made water fixtures, such as fire hydrants. The building indicates an establishment date of 1910. This undated photograph, which appears to be from around 1955, shows Tung-Sol Electric sharing space with A. P. Smith.

Eight

PEOPLE OF EAST ORANGE

The chapter features the people of East Orange, both the ordinary citizens and those who became famous.

Among the famous, author Zane Grey is alleged to have lived in East Orange and to have attended the Eastern School, but there is scant proof of this. Naturalist John Burroughs is supposed to have taught at Eastern School from 1859 to 1860, but again there is little hard evidence. Athlete "Boxcar" Bucky O'Connor, the hero of Notre Dame's victory over University of Southern California in 1930, grew up in East Orange and graduated from East Orange High School.

Actress Bette Davis lived in East Orange and attended East Orange High School for the first half of her freshman year. Silent film star Betty Bronson, born Elizabeth Ada Bronson, also attended East Orange High School. So did actress Anne Harding, who graduated East Orange High School as Dorothy Watley Gatley.

Actor Gordon Macrae was born in East Orange, but moved as a toddler. Singer Bob Dylan lived in East Orange for a brief period and cut his first tape there. Eddie Rabbitt was raised in East Orange before heading for Nashville.

Singer Whitney Houston and entertainer Queen Latifah spent much of their youth in East Orange. So did radio star Phil Cook, who lived in the city for many years. Actor John Amos was born in Newark, but moved to East Orange when he was two. He attended East Orange High School.

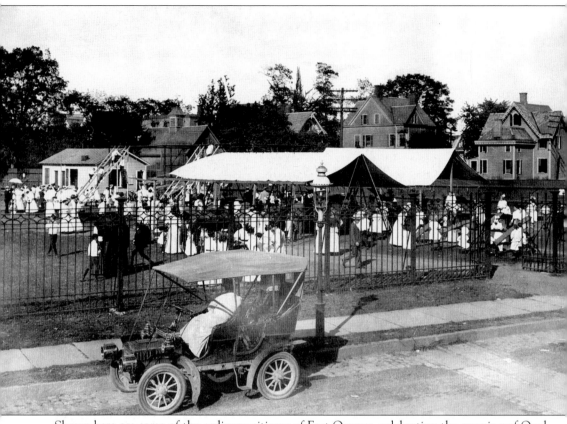

Shown here are some of the ordinary citizens of East Orange, celebrating the opening of Oval Playground on September 7, 1908. The vintage automobile has a blanket on the seat, and right behind it is one of the classic gas lamps that once lit the city. Among the other famous persons from East Orange are author W. E. B. Griffin—real name is William E. Butterworth III—who was born in Newark, but moved to East Orange as a young boy; author Sally McArt Walker, whose father was a council chairman; Uncle Wiggly books author Howard Garis, who lived for many years on Evergreen Place; oceanographer William Beebe, who graduated from East Orange High School; sharpshooter Annie Oakley, who lived for a time on Eppirt Street; and several accomplished jazz artists: Roland Kirk, Cozy Cole, Walter Davis Jr., and Slide Hampton.

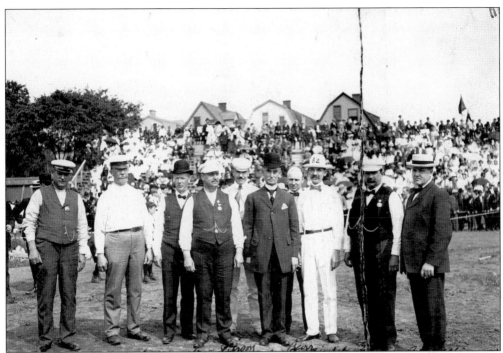

Only famous locally, members of the East Orange and Orange City Councils are ready to square off in a fund-raiser for bleachers at Ashland Field in 1907. The names written on the bottom of the photograph are not very legible, but the sixth man from the left, in the dark bowler, is East Orange mayor William Cardwell.

These men are shown in an undated and untitled photograph, but from the chalkboard on the left and the banner on the ambulance on the right, they seem to be members of the Special Ambulance, sponsored by the board of education and members of the city council.

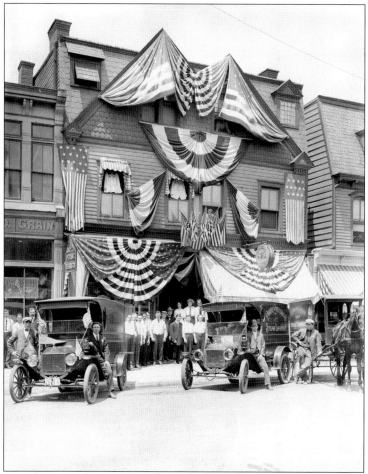

This 1913 photograph shows the workers of the Alanson R. Perine Pressing Company and Steam Laundry, located at 15 Washington Place. To the left is a grain and feed store advertising "Crescent Chick Feed" and "Globe Scratch Feed." Both trucks and the horse-drawn carriage belonged to Perine.

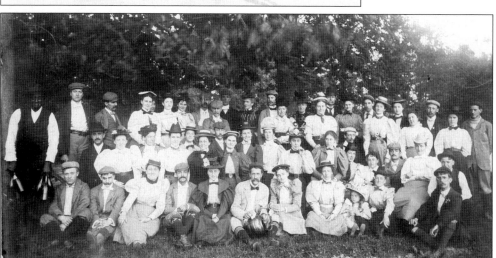

This photograph is a classic example of early-20th-century dress. These people are ready to party, as the man on the left is holding what appears to be several bottles of wine. There must have been some teetotalers, too, as the man in the front row center is polishing a large teakettle.

These men are hard at work digging a well for the Orange Water Company around 1885. Half a dozen such wells were dug and a pumping station constructed east of Grove Street, or roughly along the route of Ampere Parkway today. This well was the largest that was dug.

This photograph appears to have been taken around 1900. The man looks to be just one of the many common laborers who kept the city running. His wagon was probably used for either hauling trash or perhaps coal ashes.

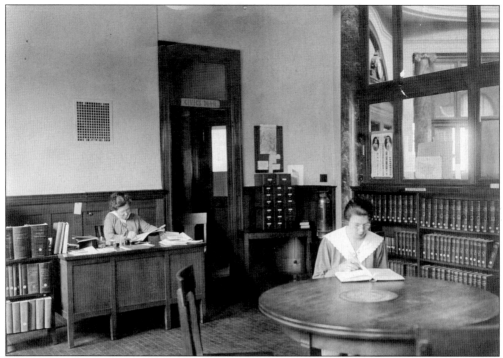

Two women are hard at work in the reference room of the main library. On the left is Alys Gordon and on the right Helen Stalker. The photograph was taken in 1916. At that time, Gordon was the head of the reference department.

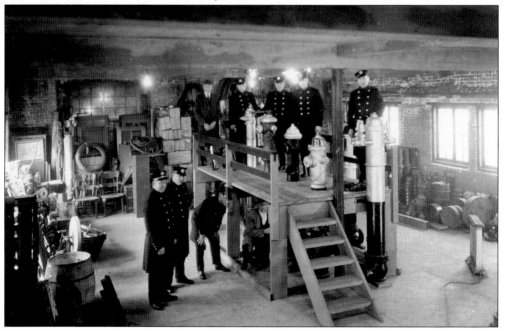

East Orange firemen seem to be inspecting new fire hydrants, perhaps having been asked for their recommendation. This photograph might well have been taken in the A. P. Smith Manufacturing Company, which produced hydrants such as these.

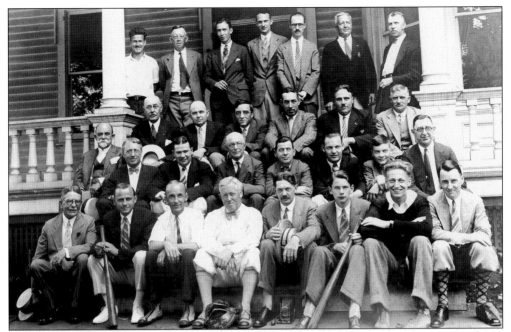

These men are members of the Franklin Club of the First Ward, and presumably some are representatives of their baseball team. This photograph was probably taken on the steps of their clubhouse, the old Anzi Dodd house on Dodd Street. The man on the far left of the second row is David L. Pierson, author and historian.

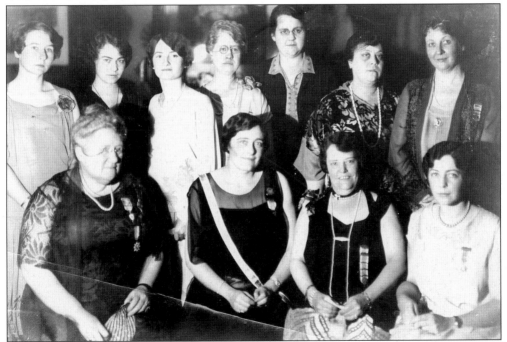

The women shown in this photograph are presumed to be associated with the First Ward Interest Club, as this photograph was found with others of that nature. The dress looks to be about 1920 or perhaps a bit later.

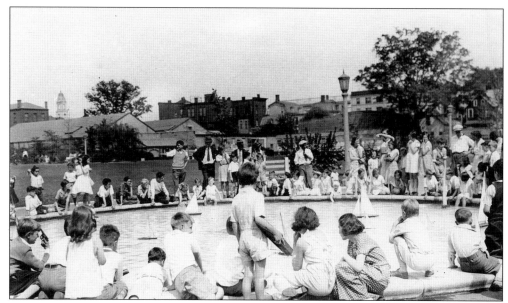

The children are racing sailboats in the wading pool at Memorial Field. The photograph was taken looking south toward Lenox Street on May 8, 1937, presumably in preparation for the 75th anniversary ceremonies.

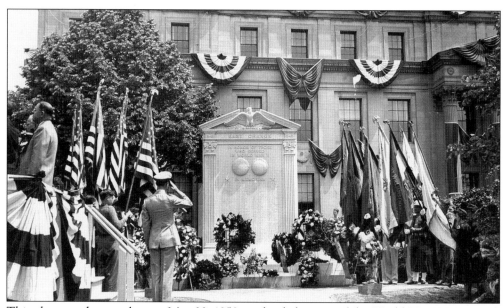

This photograph was taken on May 30, 1950, at the dedication of the World War II Memorial. The memorial, which is located on the southwest corner of City Hall Plaza, lists the names of the men and women of East Orange who served in that conflict. The entrance to city hall is on the right.

Clara Maass was born on June 28, 1876, on the south side of Elmwood Avenue, near Bedford Street. She attended Ashland School and at age 11 moved with her family to a farm in Livingston. Two years later her family returned to a house on the east side of Sanford Street, near Tremont Avenue. She completed three years of high school in Ashland but did not earn a diploma, as the requirement had just been changed to four years. She graduated from the Newark German Hospital nursing school and served briefly as a nurse, before being promoted to head nurse, but then the United States went to war with Spain. She volunteered to serve the army as a contract nurse, but the war was over by the time she got to Florida. She served in Cuba and the Philippines and then returned to Newark. When she learned about a call for volunteers to help find a cure for yellow fever, she applied. She traveled to Cuba, allowed herself to be bitten by infected mosquitoes, contracted a mild dose of the disease, and recovered. Bitten again, she fell ill and died on August 24, 1901. She is buried in the East Orange section of Rosedale Cemetery. (Courtesy of Clara Maass Medical Center / AC.)

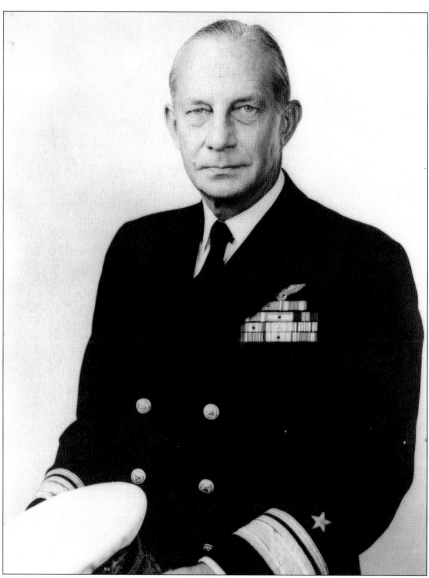

Adm. Frederick Pennoyer Jr. was born in East Orange on November 11, 1892, and grew up on Maple Avenue near Main Street. His father managed the Palmer Hotel, located at the same intersection. Pennoyer graduated from Eastern School, East Orange High School, and Stevens Institute of Technology. He then entered the Naval Academy at Annapolis, graduating in 1915 with the nickname "Horse." He served on several ships during World War I. He then studied aeronautical engineering and also earned his wings. He became convinced that the aircraft carrier and not the battleship would be the key ship of the future. He was assigned to the USS *Langley*, the navy's first aircraft carrier. He was instrumental in improving aircraft carrier design. Years later, Admiral Halsey called Pennoyer one of the "fathers of the aircraft carrier." During World War II, Pennoyer flew combat missions. He was promoted to rear admiral in 1942. After the war, remembering his old school and hometown, he sent a Japanese surrender flag that had been given to him to Eastern School. He retired a vice admiral in 1950. He died in 1971. This photograph was taken in 1948. (Courtesy Capt. Frederick W. Pennoyer III, USN (Retired) / AC.)

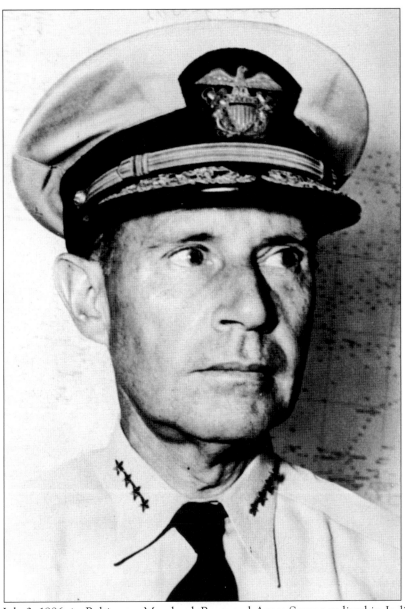

Born on July 3, 1886, in Baltimore, Maryland, Raymond Ames Spruance lived in Indianapolis until he was five. Then his mother sent him to live with his grandfather William Hiss, a wealthy man who lived on an estate at 44 South Munn Avenue in what was called the House of the White Lions, named for the two stone statues guarding the steps. Spruance graduated from Eastern School and attended East Orange High School as a freshman. After Hiss lost his fortune, Spruance returned to Indianapolis and finished high school there. Later he came back to East Orange, attended Stevens Institute of Technology, and then went on to Annapolis, graduating in 1906. During World War II, he commanded the Fifth Fleet. The hero of Midway, he planned or led the attacks at the Gilbert Islands, Marshall Islands, Mariana Islands, Battle of the Philippine Sea, Saipan, Tinian, Guam, Iwo Jima, and Okinawa. He retired a four-star admiral. Had he not been one to avoid publicity, he likely would have become admiral of the fleet. He died on December 13, 1969, and is buried alongside Adm. Chester Nimitz.

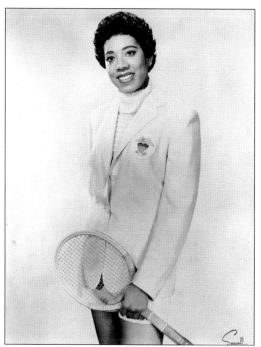

Tennis star Althea Gibson spent her retirement years in East Orange and died there on September 3, 2003. She was born in Silver, South Carolina, on August 25, 1927. A gifted athlete, she grew up in Harlem. Gibson learned tennis under the attention of Dr. Walter Johnson. She became the first black person to win at Wimbledon, the French Open, the Australian Doubles, and the U.S. Open. Gibson claimed 11 grand slam titles in total.

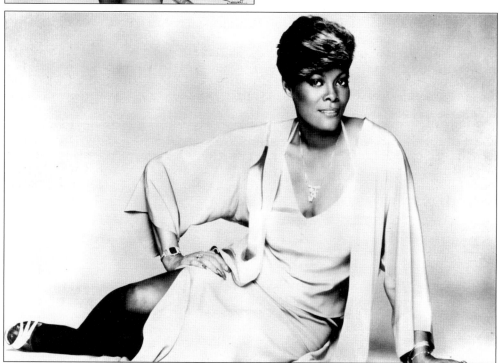

Perhaps the most famous person to come from East Orange, singer-actress Dionne Warwick was born Marie Dionne Warwick in Orange Memorial Hospital on December 12, 1940. At the time, her family was living on Sterling Street. Dionne attended Lincoln School (now renamed for her) from 1946 to 1953. She then attended Vernon L. Davey and finally East Orange High School, from which she graduated in 1959. (AC.)

Nine

RECREATION AND FUN

With no movies, radio, or television, old-time East Orange residents found other ways to have fun. There were many different clubs in East Orange. The Columbian Club, founded on January 14, 1909, built a clubhouse on the northwest corner of Grant and Roosevelt Avenues. The Women's Club of Orange, created on February 7, 1872, was the fourth women's club in America. Their clubhouse was located in East Orange at 468 William Street at the corner of Prospect Street and opened on April 18, 1906.

The Orange Club, an outgrowth of the Eclectic Dramatic Club, was incorporated on March 25, 1885. First located in the Appleton Building near Brick Church Train Station, they bought a house at 20 Prospect Street in 1887 to hold their activities. The Orange Riding and Driving Club was incorporated on June 8, 1892. In 1895, they built a clubhouse at 9 Halsted Street, which had a rear outlet on Prospect Place.

The Orange Athletic Club was incorporated in 1886. They built a clubhouse on Halsted Street, near the railroad, in 1888. They later added a tennis court and then secured a long-term lease on the Oval, located on Eaton Place. The club engaged in baseball and football games there. The Republican Club was organized around 1889. They met for several years in the Randall Building located at Main Street and South Arlington Avenue, but moved to the East Orange National Bank Building when that structure was completed.

Other clubs included the Glee Club of the Oranges, formed around 1921, which gave concerts in the auditorium at East Orange High School; the Hannah Arnett Chapter of the National Society Daughters of the American Revolution; and the Paint and Powder Club of the Oranges, formed in July 1905. The Men's Federation of East Orange was formed in 1911 and published a monthly paper for a short while beginning in January 1916. The East Orange Historical Society was formed in 1939 and met in the First Baptist Church. Clubs were not the only draw. There were dances at the armory, local theater, and many other activities. Children engaged in Little League, Boy Scouts, Girl Scouts, Cub Scouts, and Brownies. The parks of East Orange played a large role in the recreation and fun of the city. Watsessing Park, seen here near the remainder of the old mill falls, was originally planned to be a sewage disposal plant. Resistance in Doddtown and Bloomfield was so strong, however, that the idea was scuttled. Part of the plant facility was then used for the field house. This 1908 photograph looks south along the Second River. The park opened in 1900.

Oval Playground, seen here, was originally the property of the Orange Athletic Club. It was purchased by the playground commission on July 1, 1907. In October, some additional land was acquired, which gave an egress on Grove Place. The park was located on Eaton Place, east of Grove Street and north of the Grove Street Station. It encompassed six and a half acres and had full field facilities as well as tennis courts, sand boxes, and swing sets.

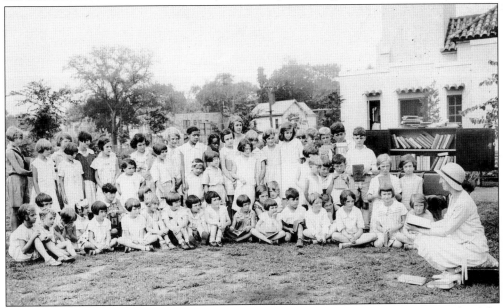

This photograph was taken at Soverel Field on July 31, 1931. Presumably it is of a story hour for children, perhaps supported by the East Orange Library. Soverel Playground was originally the site of Springdale Lake, created by Matthais Soverel so that he could harvest ice for his business. The lake was later drained. In 1922, the city bought the land for a dump.

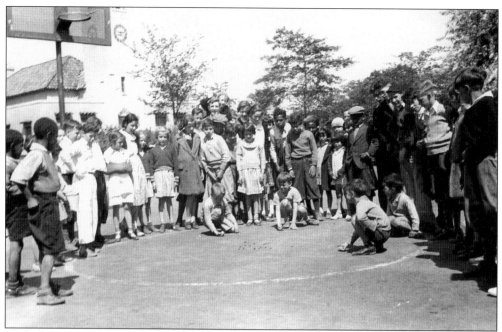

This photograph taken at Soverel Playground commemorates the opening event of the East Orange playgrounds: the boys and girls marble tournament. In 1927, the six acres of land purchased by East Orange for use as a dump was turned over to the recreation department and was opened to the public as Soverel Playground in 1929. Years later, children enjoyed playing in a gutted panther jet, which had been donated by the navy.

Columbian Playground was created on April 18, 1919, when the city purchased four and a half acres of land adjoining Columbian School. Playing fields, tennis courts, and play equipment were added, and the new playground was dedicated on September 5, 1922. The playground had no field house as it was run in cooperation with the school. Years later a boat and dock were added in which the children played.

The land for Memorial Park was purchased by the city on June 1, 1926, but did not open until 1930. It was intended principally as a World War I memorial. The memorial is being used here by these children as part of a spring festival. This photograph was taken on May 8, 1937. Each park had a similar spring festival with costumed dances, plays, a maypole, and the crowning of a king and queen.

Elmwood Park was originally nine acres of land acting as a dump, but was rescued in 1910 when the land was purchased to become a park. In 1917, Alden Freeman began developing the park in memory of his father, Joel Francis Freeman. Alden Freeman had a series of statues designed by Ulric H. Ellerhuson for the park entitled the Shrine of Human Rights. Besides the *Altar of Democracy*, shown here, they included busts of Pocahontas, Columbus, Confucius, and Frederick Douglass, visible in the background.

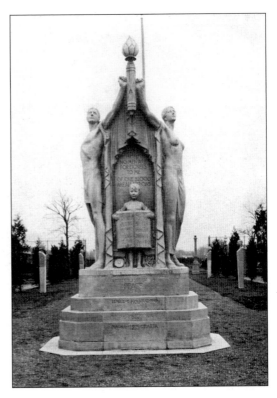

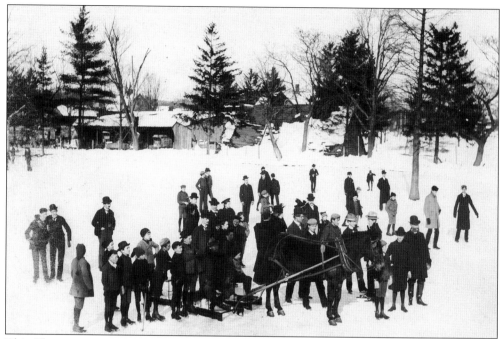

This Christmas morning 1896 view shows the skating pond at Soverel Field, at the corner of Springdale Avenue and North Park Street. People used the Springdale Lake for skating for many years until it was drained.

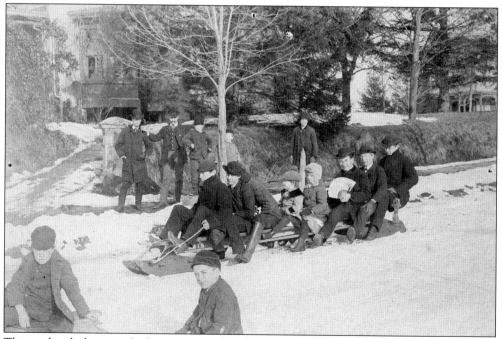

This undated photograph shows men and children sledding down William Street. There are no identifying captions or landmarks. It appears to have been taken around 1880. Judging from the gentle slope of the hill, the riders may be heading east from around Twenty-first Street to Greenwood Avenue.

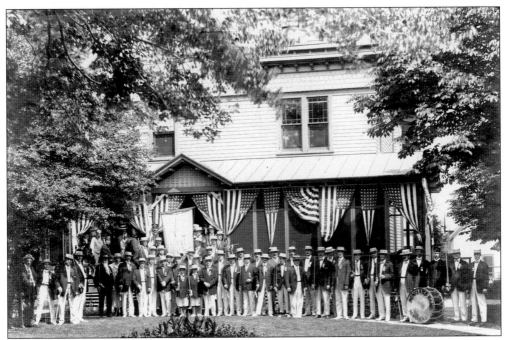

The first lodge of the Benevolent and Protective Order of Elks outside of Newark was created in the summer of 1889 and took up residence in the Post Building at the corner of Main and Washington Streets in East Orange. Their designation was Orange Lodge No. 132. The Elks are shown here years later in 1913 in front of their clubhouse at 10 North Arlington Avenue.

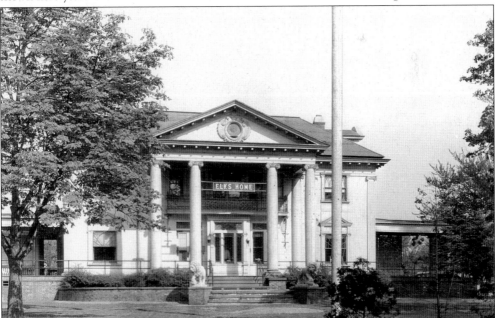

The Elks later moved to 44 South Munn Avenue, purchasing the House of the White Lions. This was the old Hiss Estate mentioned previously as the home of Admiral Spruance's grandfather. The lions are still on guard in this photograph, and other than an "Elks Home" sign, little appears to have changed from earlier photographs.

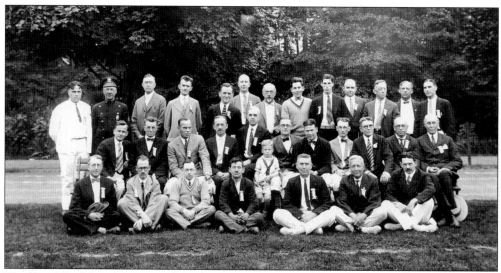

The First Ward Local Interest Club was organized on an April evening in 1909 and was made permanent in September. The club influenced civic projects and produced a monthly newsletter beginning in April 1918 that lasted almost 10 years. The club met at the old Amzi Dodd house on Dodd Street and Fulton Avenue.

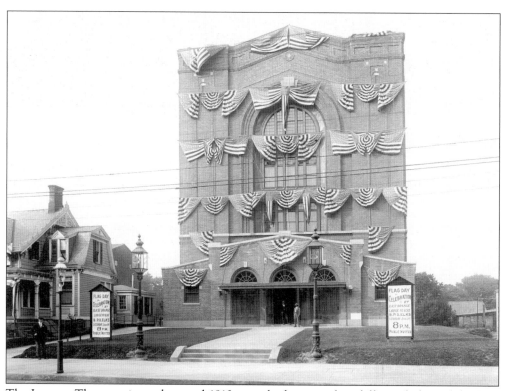

The Lyceum Theater, pictured around 1913, was the home to four different lodges of the Free and Accepted Masons. Located on the north side of Main Street west of Halsted Street, it later became known as the Ormont Theater and, along with the Ampere, Beacon, Hollywood, and Palace (on the Orange border), served East Orange.

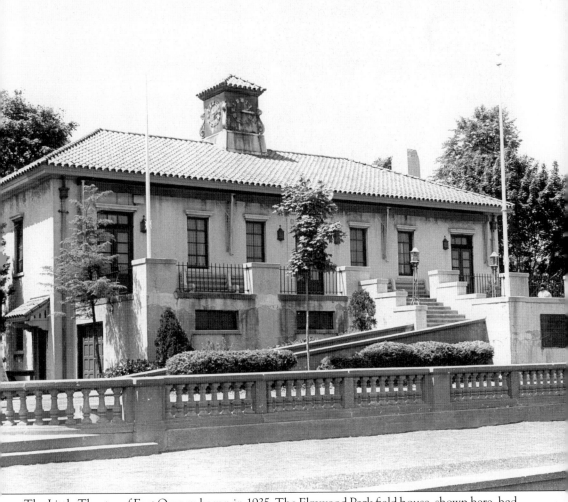

The Little Theater of East Orange began in 1935. The Elmwood Park field house, shown here, had just been heated. At the same time a small stage measuring 16 feet by 10 feet was added. Equipped with lighting and a draw curtain, it was perfect for a children's theater, which immediately got underway. With the Depression in full swing, Francis H. Haire, recreation superintendent, had an idea that an adult Little Theater might help the community. With all of the talented people in the area and perhaps some financial backing from the department, she believed it could work. To test the idea, a Drama Institute was started. It was so well received that a Little Theater was formed with a board of directors and by-laws. Things were fragile in the beginning. Samuel French Inc. refused to grant credit. The cast bought their own books, and several members came up with the $100 play royalties. Ironically, Samuel French was later willing not only to give the theater credit, but also gave it discounts and used the group to try out new Broadway releases. In 1936, the amateur group opened its first season.

The first play to appear on the Little Theater stage was *You and I*, during March 1936. The play was written by Phillip Barry and directed by Howard Bailey. Hundreds of photographs were taken of the Little Theater productions. This is the very first one. From left to right are Angela Bittman, Howard Bailey, Denton Varley, Esther Lawrence, and Sid Mitchell.

The theater continued successfully during the 1930s and into the 1940s. When World War II came, the shortage of men severely brought the group down in number. Thirty-five male members were in the armed services by November 1943, and the theater decided to cease production. Shown here is the 1941 show *Ladies in Retirement*, which ran from December 1 to 6 and was staged by longtime Little Theater director Jack Leahy.

Agatha Christie's *Ten Little Indians* came to the Little Theater stage December 8–13, 1947. With the war over things were picking up again. Directed by Dorothy Earle, it starred, from left to right, Larry Redman, Jane Disbrow, Harry McEwen, James Groves, Carl Lederer, Marc Smith, Marion Blasi, Mildred Banerle, and Harry Gross.

The Little Theater boomed throughout the late 1940s and the decade of the 1950s. Shown here is *The Happiest Millionaire*, which ran May 8–13, 1959. Directed by Jack Leahy, the stars from left to right are Grace Riehm, Myra Semel, John Mieskalski, Gilbert Longo, John Roberts, Robert Douglas, Carl Lederer, and Anthony Falzarano.

The Little Theater moved to new quarters at the Elmwood School in 1958. The new stage provided better sets, lighting, and sound. The group reached new heights when it took on Arthur Miller's *Death of a Salesman*. Directed by Jack Leahy, the actors shown here from left to right are believed to be Vincent LaMartine, Jane Schober, Mario Cassara, and Leonard Tepper. The play appeared March 21–26, 1960.

With decreasing audiences, the Little Theater deemed it was time to close its doors. The 35th season was the final one for this award-winning thespian group. The final play, shown here, was Neil Simon's *Barefoot in the Park*, directed by Vincent LaMartine. It starred Ted Sugges (left) as Paul Bratter and Jackie Smollen (right) as Corie Bratter.

Ten

CELEBRATIONS AND FAREWELLS

This book has been a celebration of the life and history of East Orange, so what better way to end it than with a series of photographs showing the citizens of the city having fun.

The largest celebration to hit East Orange and its neighbors was probably the Centennial of the Oranges. Occurring over six days in June 1907, it resulted in nearly every major building being decorated with bunting. There were parades, speeches, athletic games, banquets, and fireworks (the night of Saturday, June 15). Thousands turned out for these events, and they lined the streets to see the parade.

The next big celebration to hit East Orange came in 1913 when the city celebrated its 50th anniversary. While limited to the city, there was still a huge parade and again the assortment of speeches, presentations, memorials, dinners, and so on.

In 1919, when the doughboys returned, they were welcomed in style. The same occurred in 1945. Memorials were erected and dedicated to remember the fallen. In between there were other celebrations. Parks were dedicated, flags were raised, and boy scouts had jamborees.

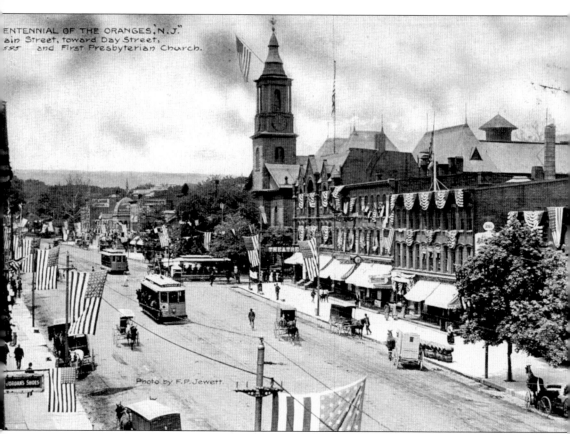

Photo by F.P. Jewett.

The Centennial of the Oranges celebration was planned well in advance. Fully recognizing that the government was instituted on April 13, 1807, the main celebrations were postponed until June 9–14, 1907, in hopes of better weather. This view of a decorated Main Street looks from the edge of East Orange west toward Orange and the First Presbyterian Church. Notice the theater marquee dead center. In later years, the city celebrated its 75th celebration with gusto. This book owes a lot of gratitude to that event. City hall collected many old photographs and took many more to commemorate the event. A short history was written, and many photographs were preserved in that piece of work. In 1963, the city celebrated is own centennial with various programs of enjoyment. Once more photographs were collected and a more detailed history written, filled with facts and pictures. Many commemorative items were manufactured, too, and these keepsake plates, ashtrays, and medallions can still be found today. Two years later, East Orange joined in the 300th anniversary of the Oranges, commemorating the purchase of additional lands on Orange Mountain and the survey of John Dod.

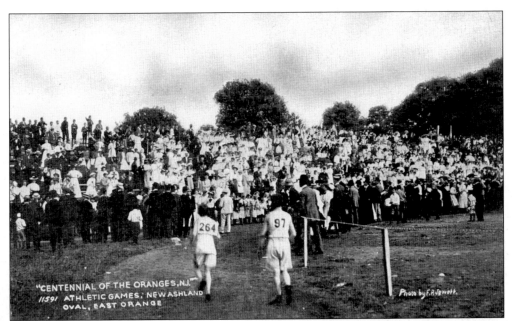

Games were a big part of the Centennial celebration in the Oranges. Here is a track meet at the Ashland Oval. The five-acre Ashland Oval was purchased for $8,000 in 1905 by the board of education. Citizens collected another $1,800 and had bleachers constructed. East Orange High School then moved its athletic events to this location from the Oval on Eaton Place.

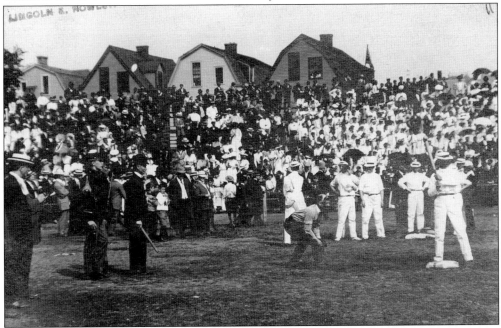

This is a baseball game being played between the East Orange City Council and the Orange Town Council on Saturday, June 15, 1907. The location was again Ashland Field. In 1920, the city sold $100,000 in bonds to build Ashland Stadium here. It held 8,000 people and was the location of all large city sporting events and celebrations. The stadium was later renamed Martens Stadium after the longtime mayor.

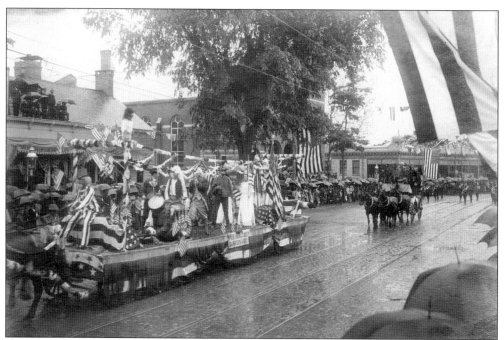

While unmarked, this is believed to be one of the floats of the 1907 centennial celebration. The writing on the float is mostly illegible, but seems to say in part, "Orange Council Daughters." As the float riders are dressed in Colonial garb, this may have been the Orange Chapter of the Daughters of the Revolution. The float is heading west and has just passed Brick Church.

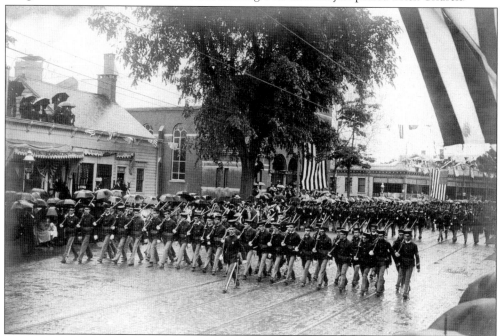

This is another undated and unmarked photograph, but it is also believed to be from the centennial parade. This military group is also heading west and has just passed Muirs and Brick Church. The store on the left is No. 506 Main Street, H. S. Johnson.

Decorations were everywhere. Looking north, this *c.* 1907 view shows Main Street at Prospect Street. On the right is Muirs Department Store. Ralph H. Muir came to America from England. He opened his first dry goods store near Brick Church in 1881. He and his brother Arthur opened a store at this location around 1906. On the left is Brick Church.

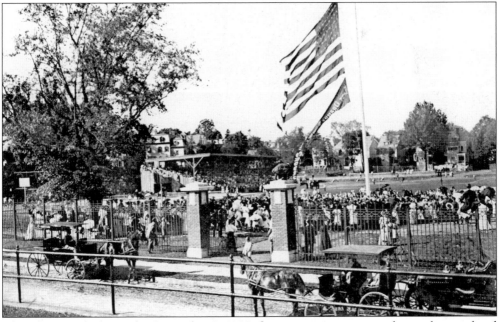

This photograph shows the September 7, 1908, flag-raising ceremony at the newly completed Oval Playground. This view looks north and was probably taken from the Grove Street Station. Besides the two horse-drawn carriages, notice that there is a vintage automobile visible in the lower right-hand corner.

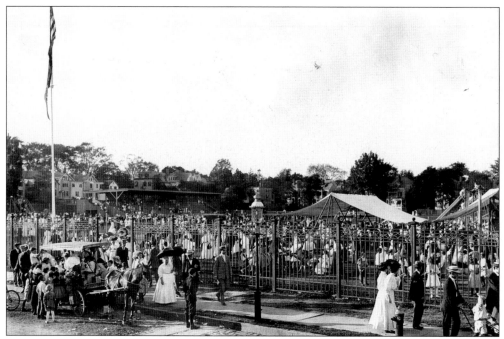

This is another view of the daylong celebration, which also included various sporting events. Again looking north (on the left side, center) one can see the bleachers that overlooked the playing field. In the center, people are trying out the "teeter-totter." The wagon on the left is surrounded by children and may have been an early ice-cream truck.

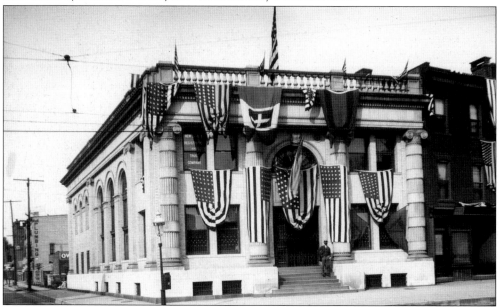

History is not always exact. This photograph and the next were developed from plate glass negatives. The crumbling envelopes in which they were found clearly indicate that they were taken on June 12, 1907. However, the flags have 48 stars. When the Centennial of the Oranges was celebrated, there were only 45 states. There were 48 states during the 50th anniversary celebration. This view is of the People's Bank.

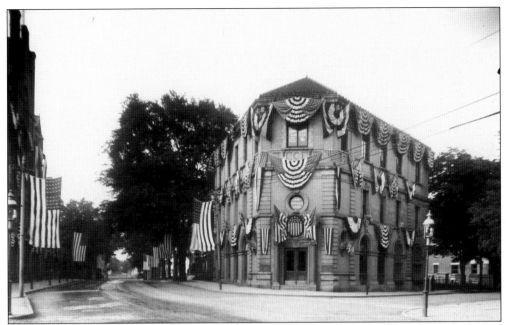

Whether 1907 or 1913, the pictures are wonderful. This shot shows the Essex County Trust Company Building at the intersection of Main Street (left) and South Arlington Avenue (right). The Republican Club met in this building, and its name can be seen in the round window. The Hope Lodge met on the upper floor, and its name can be seen in that window.

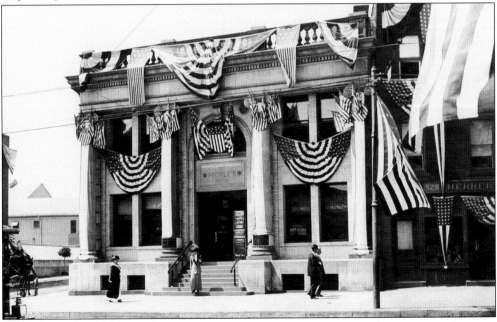

This is another undated photograph of the People's Bank. Main Street is the cross street. Prospect Place is off to the left. The store to the right, at 529 Main Street is a market owned by Herbert J. Condit. Farther west (right) and out of view was an "apartment" called the Prospect followed by the grocery store of W. W. Jacobus and Company. Jacobus was a competitor of Decker and operated in East Orange for many years.

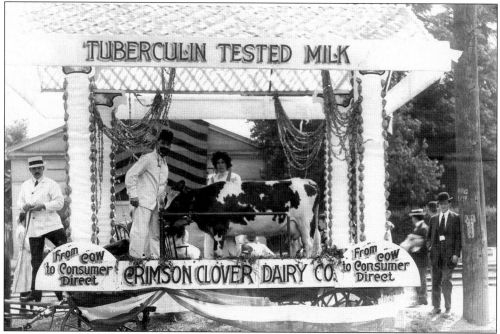

In 1913, East Orange celebrated its 50th anniversary. Planning began at the city council meeting on Monday, March 12, 1912. A committee was formed and headed by Frederick Saxelby. A banquet was planned for March 4, 1913, but the parade and other celebrations were planned for June. Here is the float of Crimson Clover Dairy Company.

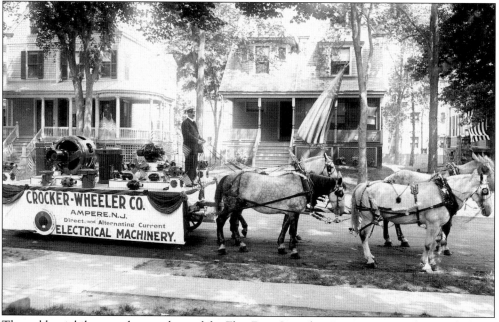

The golden jubilee parade was planned for Flag Day, Saturday, June 14, 1913. The marshal was George P. Olcott. The start of the parade was set for Harrison Street and Central Avenue. Shown here is the float of Crocker-Wheeler Company. Crocker-Wheeler came to East Orange in 1893. With its arrival came the development of the Ampere section.

The parade passed down Central Avenue, turned north at the Parkway (Oraton), then headed to Park Avenue where it turned west. The parade route proceeded on Park Avenue to Prospect Street. From there it headed south to William Street where it turned west again, proceeded in that direction to North Harrison Street and turned south. The parade then headed east down Main Street. The parade is passing Nassau School in this photograph.

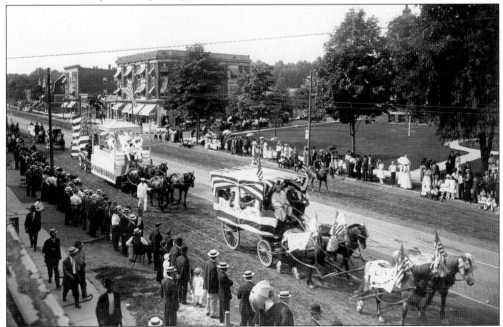

The Nassau School, out of view here, was completed in February 1899 and located west of North Arlington Avenue on the north side of Central Avenue. The large float on the left is the Seabury and Johnson float. The parade, turning east down Main Street, ended at city hall before a reviewing stand headed by Mayor Julian A. Gregory.

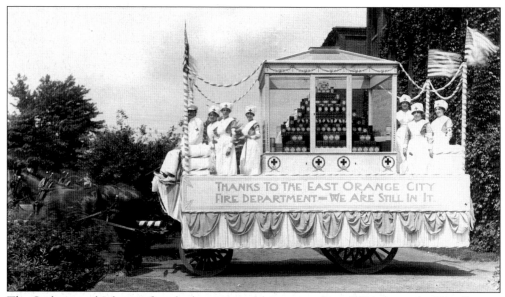

The Seabury and Johnson float had an unusual banner reading, "Thanks to the East Orange City Fired Department We Are Still In It." One week earlier the plant had caught fire. There was $50,000 worth of damage, but the East Orange Fire Department managed to stop the blaze. Seabury and Johnson was a pharmaceutical firm located on Glenwood Avenue near Glenwood Place and the Erie Railroad tracks.

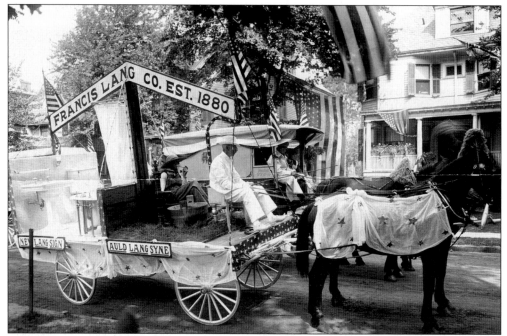

Here is the Francis Lang Company float. Established in 1880, the Francis Lang Company engaged in plumbing and plumbing supplies. This humorous float depicts an old-fashioned washtub in the front portion displayed against shiny, new porcelain figures in the rear of the wagon. The caption is "Auld Lang Syne (versus) New Lang Sign." The company was headquartered at 378 Main Street, East Orange.

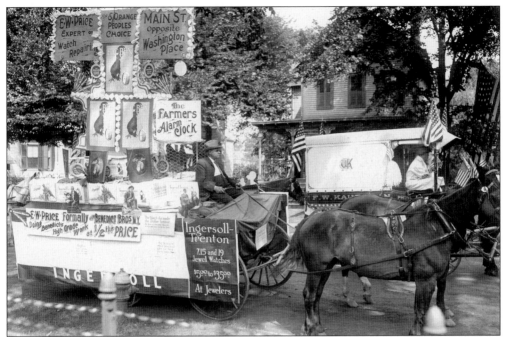

Shown here is the Ingersoll-Trenton float. Located on Main Street opposite Washington Place, the company sold watches and clocks and also engaged in watch repairs. Behind that float is the decorated vehicle of Frank W. Kaufman. Kaufman was in the grocery and produce business with stores at 417 Central Avenue, 382 Main Street, and 37 Oak Street.

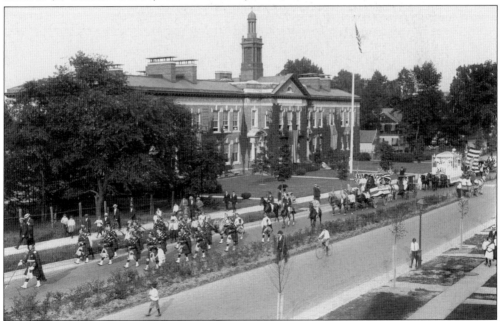

As mentioned previously, the parade wound round the city and headed west up Park Avenue. Here the parade is passing by Ashland School. The bagpipers and floats are not identified. Notice the many people walking along with the parade—although the Park Avenue crowd is certainly thinner. Many probably viewed the parade from their homes.

The only known President of the United States to visit East Orange was William Howard Taft. Shown here (the hatless man at the base of the statue), he is placing a wreath at the base of the Lincoln Statue on February 9, 1912. The Lincoln Statue was designed by sculptor Frank Edwin Elwell. It was located on the (Oraton) Parkway near New Street and dedicated on June 14, 1911. It was relocated to city hall in the 1950s.

This may be the celebration of returning World War I soldiers, held on June 14, 1919, although records indicate that the parade proceeded east and not west, as these men are marching. Brick Church is center left while Muirs is center right.

The troops are heading west and have passed Brick Church on the left. On the left is a barbershop. On the far right is an Orange Trolley Car. The trolley line on Main Street was started in 1862, but East Orange disallowed Sunday service until 1873. The line was electrified on January 27, 1892. It was replaced by buses on March 1, 1951.

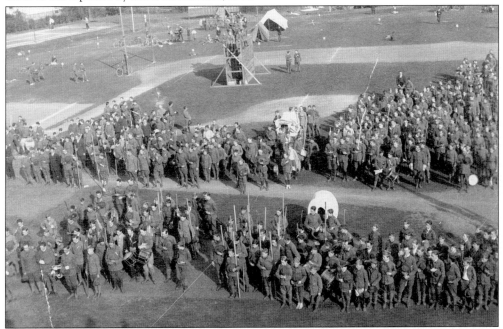

The Boy Scouts came to East Orange on December 20, 1912. They met at the Arlington Avenue Presbyterian Church. A first class council was instituted in East Orange in 1915, and this photograph, taken in the same year, may have been a celebration of the same. The photograph is dated October 9, 1915, and was taken at Oval Playground.

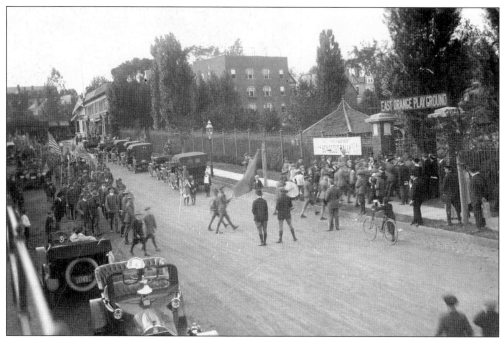

This photograph, presumably taken a bit earlier that day, shows the Boy Scouts marching into the Oval Playground. The Oval was officially called the East Orange Playground, as indicated by the sign over the gate. The white sign in the center reads, "Be Prepared. Come. Boy Scout Rally. Oct. 9th 1915." This view looks west up to Grove Street.

East Orange celebrated the 150th anniversary of the United States with games, contests, and fireworks. This photograph was taken on July 5, 1926, in Watsessing Park at 7:30 p.m. Each of the girls represents an original colony. From left to right are Mary Crawford, Lillian Kutcher, Dorothy Searing, Cynthea Gordon, Beatrice Cross, Marion McCollum, Marjorie Gerry, David L. Pierson (historian), Hazel Lee, Lillian Lee, Edith Crawford, Pearl Davis, Marie Felton, Helen Ottinger, and Miriam Reeve.

Not all celebrations were big ones. Some small ones were even more memorable. This modest house displays flags and a banner to welcome home Captain Stanley from World War II. The sign was provided by the "Lackland Post 7923 V.F.W. East Orange." The location of this house is not known nor are their any details available on the Captain.

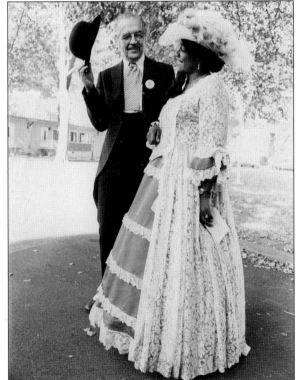

In 1978, the city of East Orange celebrated the 300th Settlement Day of the Oranges. People gathered in period dress and engaged in all types of celebratory games and demonstrations at City Hall Plaza. Here are councilman Bernie L. Edmonson and Constance L. Newton in their old-fashioned garb. The councilman's "tip of the hat" brings a fitting conclusion to this book.

BIBLIOGRAPHY

Buell, Thomas B. *The Quiet Warrior: A Biography of Admiral Raymond A. Spruance*. Boston, MA: Little, Brown, 1974.

The East Orange Record, The Centennial Edition. Orange, NJ: Worrall Publications, May 2, 1963.

The East Orange Record. Various. Orange, NJ: Worrall Publications, 1942-1943.

Folsom, Joseph Fulford (ed). *The Municipalities of Essex County New Jersey 1666-1924 Vol I-IV*. New York, NY. Lewis Historical Publishing Co., 1925.

Garis, Roger. *My Father was Uncle Wiggly*. McGraw-Hill Book Company, 1966.

Kasper, Shirl. *Annie Oakley*. University of Oklahoma Press, 1992.

Kinney, Kevin. *East Orange Settlement Day*. 1976.

Leaming, Barbara. *Bette Davis: A Biography*. New York, NY: Summit Books, 1992.

Peabody, Robert T., Chairman. *Seventy fifth Anniversary: the City of East Orange New Jersey*. Orange, NJ: Coyler Printing Company, 1938.

Pierson, David Lawrence. *History of the Oranges to 1921*. Vol. I-IV. New York: Lewis Historical Publishing Co., 1922.

Shaw, William H. *History of Essex and Hudson Counties, New Jersey Vol. II*. Philadelphia: Everts & Peck, 1884.

Stuart, Mark A. and Jessie W. Boutillier. *A Centennial History of East Orange*. East Orange Centennial Committee, 1964.

Vespucci, Richard and Donna Lee Goldberg. *A History of East Orange*. Orange, NJ: Worrall Publications, 1976.

Whittemore, Henry. *The Founders and Builders of the Oranges*. Newark, NJ: L.J. Hardham, Printer and Bookbinder, 1896.

Wickes, Stephen. *History of the Oranges in Essex County, NJ, from 1666 to 1806*. Newark, NJ: Ward & Tichenor, 1892.